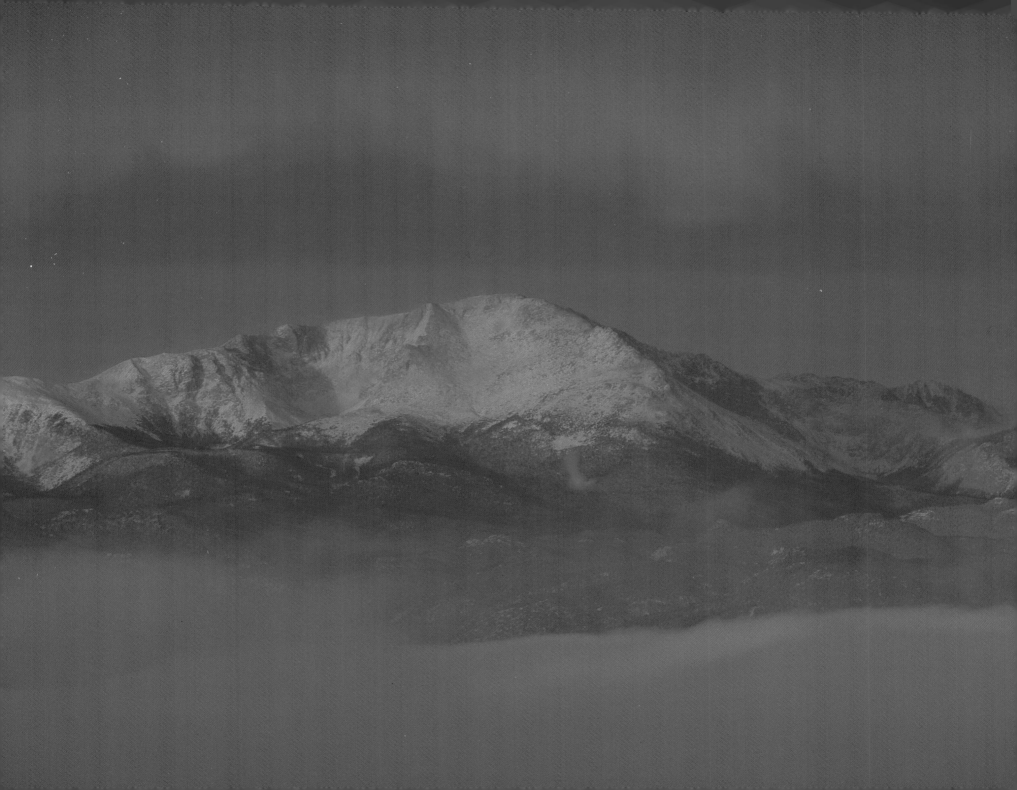

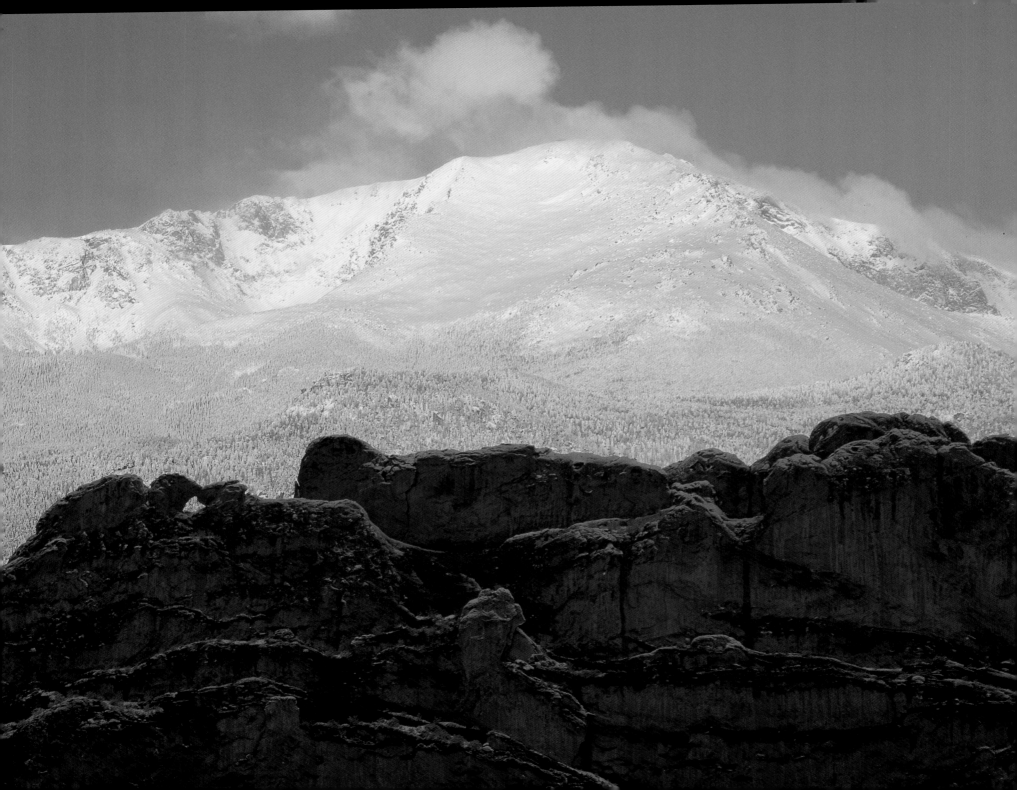

PIKES PEAK & GARDEN OF THE GODS
Two Worlds~One Vision

Photographic Portfolios by
Todd Caudle

Published by

Skyline Press

Pueblo, Colorado

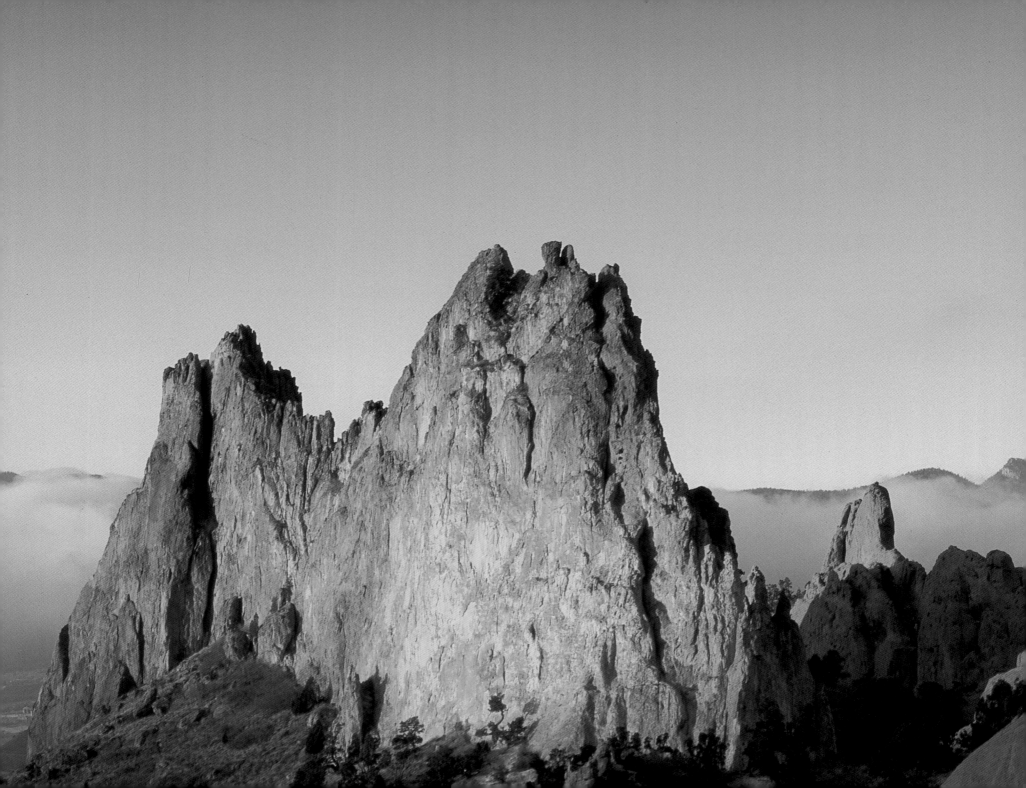

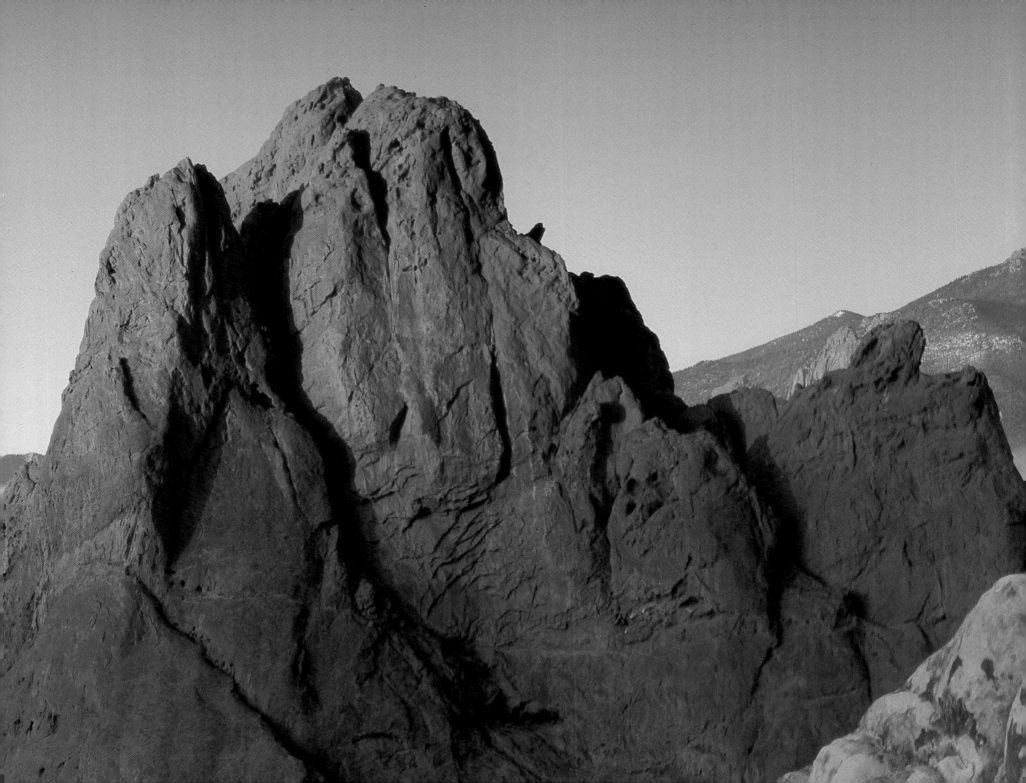

Pikes Peak & Garden of the Gods

Two Worlds~One Vision

Photographic Portfolios
by

Todd Caudle

Book design and layout by Todd Caudle
Editing by Jane Turnis

First frontispiece: Alpenglow sunrise, Pikes Peak from Palmer Park
Title page: Heavy snowfall on Pikes Peak, preceded by Kissing Camels silhouette
Previous page: Low clouds beyond Garden of the Gods
Left: Sandstone detail and Pikes Peak
Opposite: Colorful sunset, Kissing Camels
Overleaf: Juniper snag and the Gateway

ISBN: 1-888845-00-7
Printed in Korea

Skyline Press
311 West Evans Avenue
Pueblo, CO 81004

Dedicated with love to my mother,

who, in 1970, moved our family

to this glorious place

we call home.

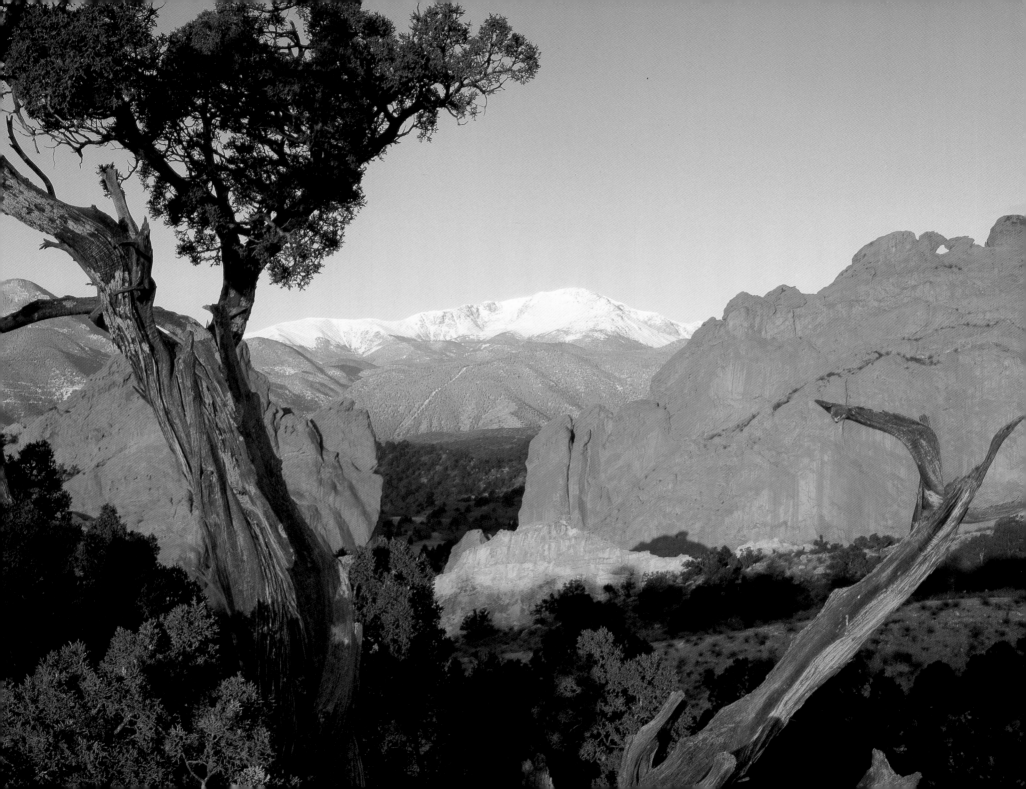

Table of Contents

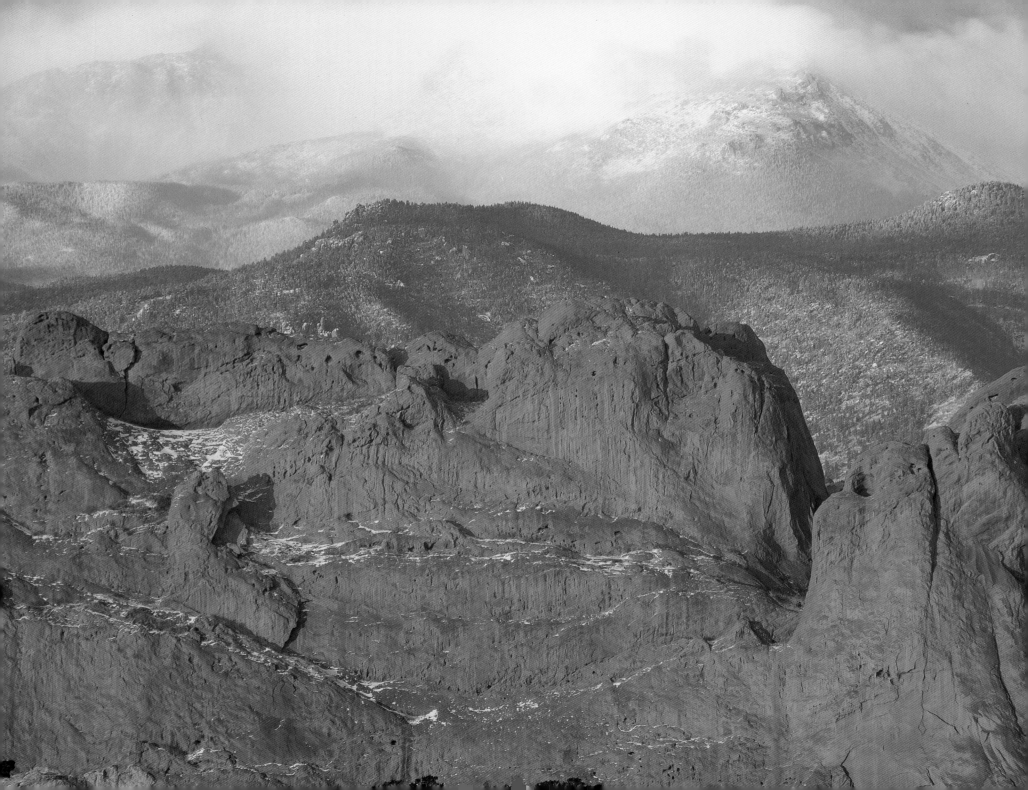

Introduction

I moved to the Pikes Peak region in 1970, when my family followed my oldest brother, Rich, to the area after his appointment to the U.S. Air Force Academy north of Colorado Springs. Everything I did growing up, I did in the shadow of Pikes Peak.

As a teenager, I frequented Garden of the Gods with friends, where we scampered across the smooth sandstone formations and reveled in the warmth of sunny summer afternoons.

When it came time to explore my artistic side, my first medium was pencil and paint. Later, I turned to the immediacy of the camera. My brother, Steve, had grown fond of photography, and although I was unbelievably dense when it came to understanding the photographic process, he patiently drilled basic concepts into my head until they started making sense. Photography quickly became a hobby worthy of consuming every extra dollar I earned.

Pikes Peak and Garden of the Gods were obvious photographic subjects for me. They were both incredibly beautiful, and they were both close to home. In those early days I exposed frame after frame of the area, coming back with lots of mediocre photographs, but learning from each one.

Then something changed. I lost interest in subjects close to home, in favor of the distant lands of southern Utah. It took just one embarassing situation to bring me back home.

My accountant had suggested that we trade a photograph of mine for her services. Since her husband had run the Pikes Peak Marathon, she thought a picture of Pikes Peak would look good on his office wall. I timidly admitted that I had nothing worthy of displaying, but promised her that if she gave me a few weeks, I'd make amends.

On my first outing to rediscover Pikes Peak and Garden of the Gods, I got lucky. It was April and I drove my Chevette up Rampart Range Road on a very foggy morning. I just had a feeling. The car's wheels were firmly lodged in grooves as I passed over deep snow, the undercarriage scraping all the way. Soon enough, the fog was below me, and I was staring at a mountain that rose through the grayish din below. I got a stunning shot for the marathon runner's wall.

That dilemma solved, I began a photographic odyssey that continues to this day.

These days, hardly a day goes by when I don't at least think about going out to the Garden to take some photographs. I watch weather reports and moon calendars religiously, and if something extraordinary is in the forecast, I'm out the door long before the sun comes up.

On those days that I decide to forego a Garden adventure, I feel like I'm missing something. I live only 15 minutes from the Garden, and I can see Pikes Peak from almost anywhere in the city, but it takes forethought to be at a perfect location when the light is happening, or when a storm is breaking. There is simply no more exciting feeling in the world than knowing you've captured a little slice of nature's exquisite beauty on film.

More often than not, these moments are not shared with anyone else until the film comes back from the lab. I am constantly amazed at how often I witness a spectacular sunrise on the Peak and the Garden, and no one is there to watch it with me.

Aside from all the wonderful photographic moments nature has bestowed upon me, I will always consider my time with Pikes Peak and Garden of the Gods as some of the most magical of my life.

— Todd Caudle
Colorado Springs

Lingering storm, Pikes Peak (14,110') and North Gateway Rock

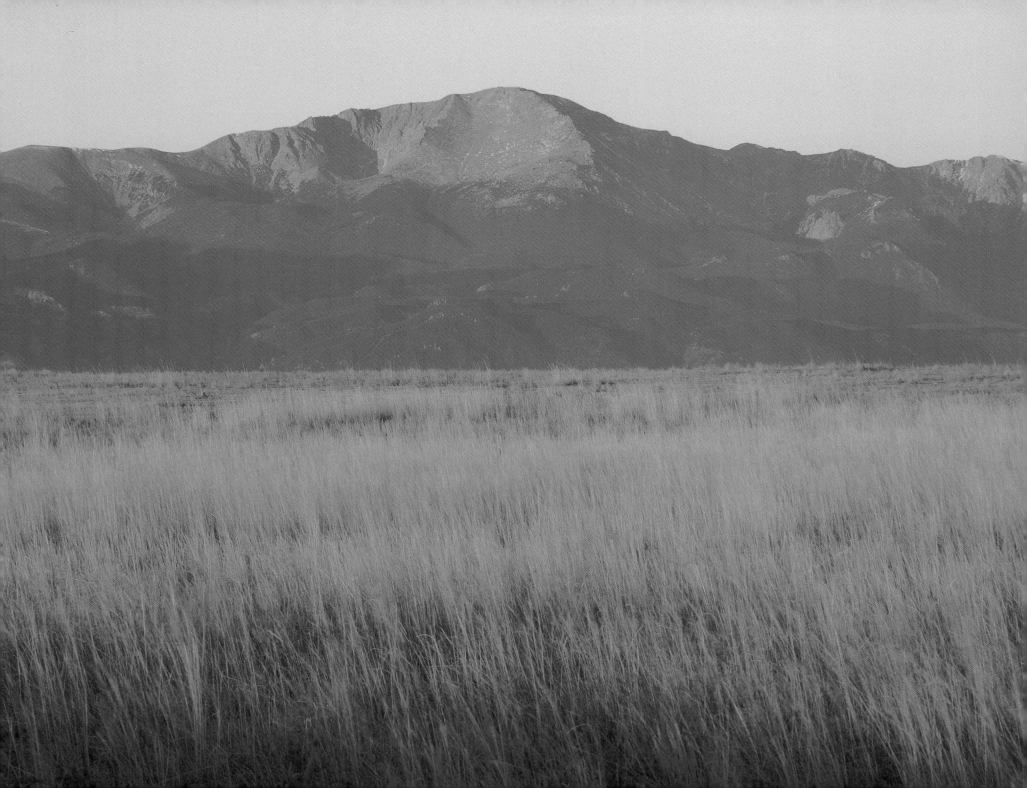

Pikes Peak

Rising from the Plains

What must it have been like for Zeb Pike to see the mountain that would one day bear his name? Army Lieutenant Zebulon Montgomery Pike was the young leader of an 1806 expedition sent to explore the southern boundary of the newly acquired Louisiana Purchase. He and his men made their way across the Great Plains into Colorado, where they got their first glimpse of the mighty mountain range that rose on the western skyline. The Mexican Mountains, he called them, owing to the region's former claimants.

From north of present-day Pueblo, Pike and three men – a doctor and two army privates – set out to climb the tall peak to the north, thinking it was much closer than it was. The month was November, and Pike and his men were ill-prepared for the weather conditions on the mountain. His journal entry for November 25th, 1806, read, "Rose early, with an expectation of ascending the mountain, but was only able to camp at its base, after passing over many small hills covered with cedars and pitch pines."

Expecting to leave their base camp and reach the peak's summit the following day, the party left their supplies behind and attempted the ascent without provisions. Again, their attempts were thwarted, as the mountain was still farther away than they had anticipated. Part way up the peak on the 27th, Pike described in his journal a scene as beautiful today as it must have been two centuries ago.

"Arose hungry, dry, and extremely sore, from the inequality of the rocks,

on which we had lain all night, but were amply compensated for toil by the sublimity of the prospects below. The unbounded prairie was overhung with clouds, which appeared like the ocean in a storm; wave piled on wave and foaming, whilst the sky was perfectly clear where we were."

Pike had experienced a phenomenon called upslope, when cold air masses and their accompanying cloud cover move in from the east and pool over the plains, leaving the mountains of the Front Range jutting above, into endless blue sky.

The challenge of climbing the peak was too much for Pike and his men, however. They encountered waist-deep snow and were still far from the top.

"The summit of the Grand Peak, which was entirely bare of vegetation and covered with snow, now appeared at the distance of 15 or 16 miles from us," Pike wrote, "and as high again as what we had ascended. . ."

He turned back before reaching his goal, proclaiming, "I believe no human being could have ascended to its pinacal [*sic*]."

Today, the summit of Pikes Peak is the most visited mountain summit in Colorado. A hike up the Barr Trail, a ride on the cog railway, or a scenic 19-mile drive up the Pikes Peak Highway will put a visitor to Pike's mountain on that pinnacle that he never got to see for himself. But that hardly makes the Grand Peak any less grand. Pikes Peak will always be a majestic sentinel, rising from the plains, keeping watch over generations of pioneers.

Sunrise over the Great Plains
Left: Prairie grasses

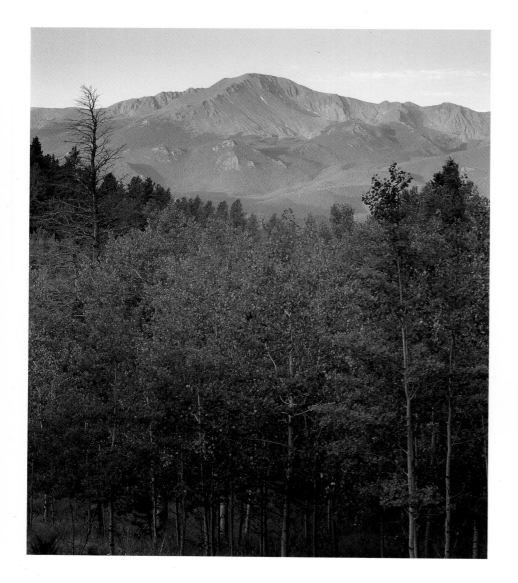 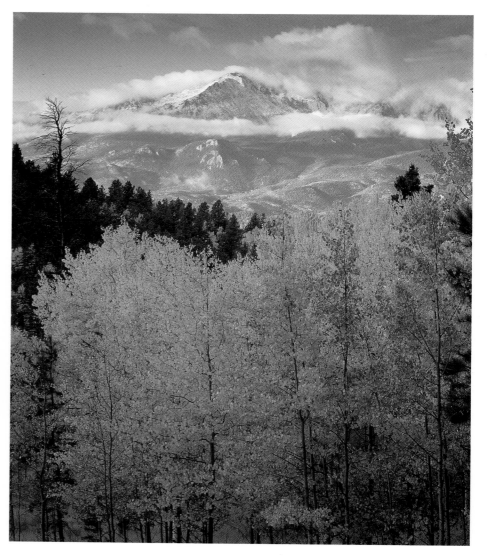

Pikes Peak, four seasons: Summer, Autumn. . .

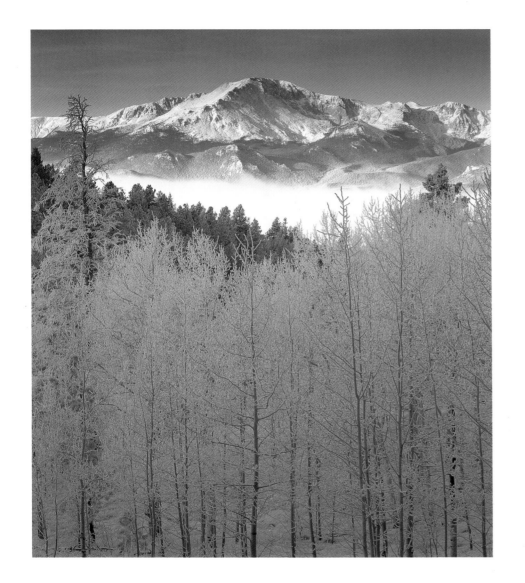

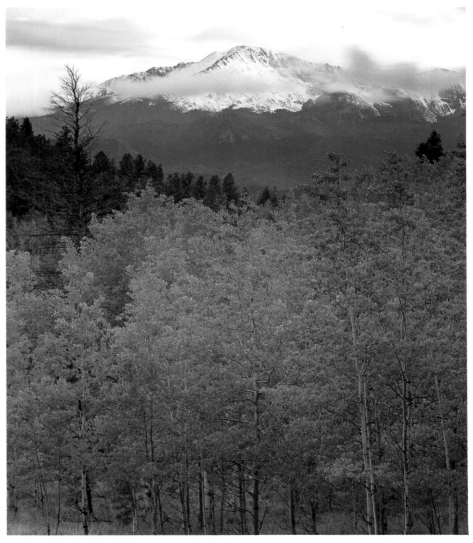

. . .Winter, Spring

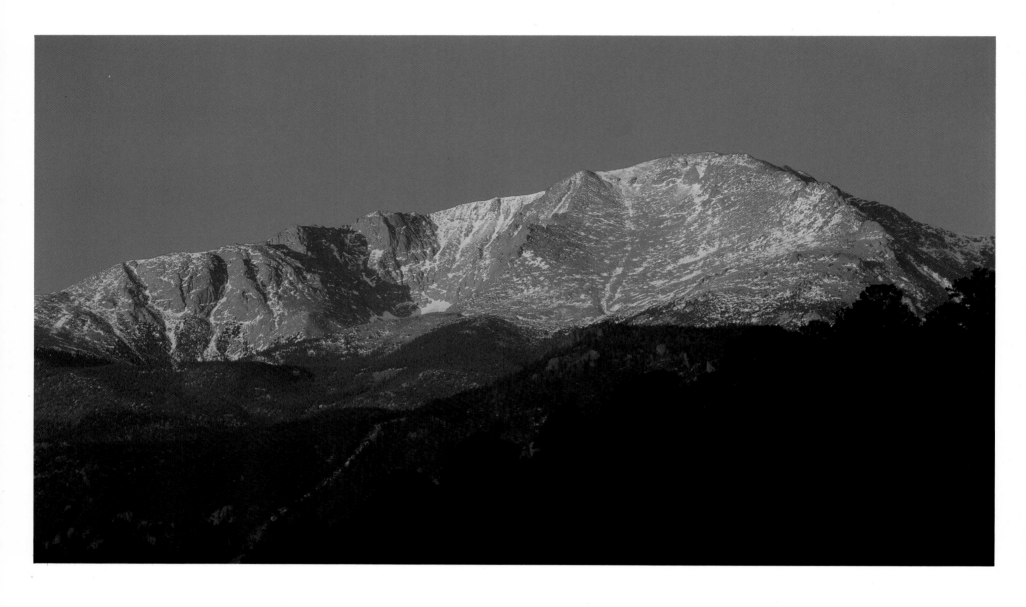

Another glorious sunrise

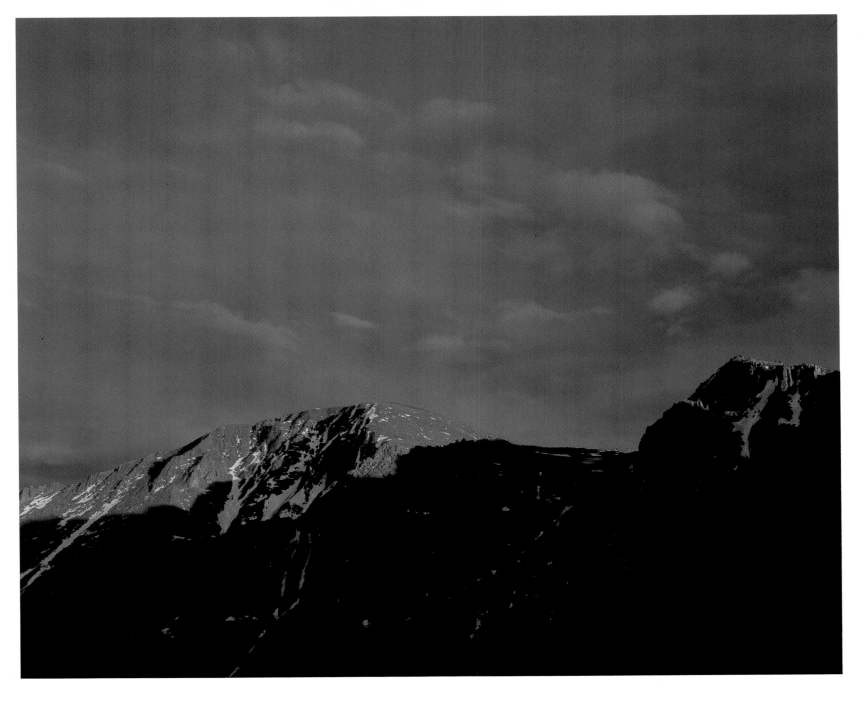

Last light of day

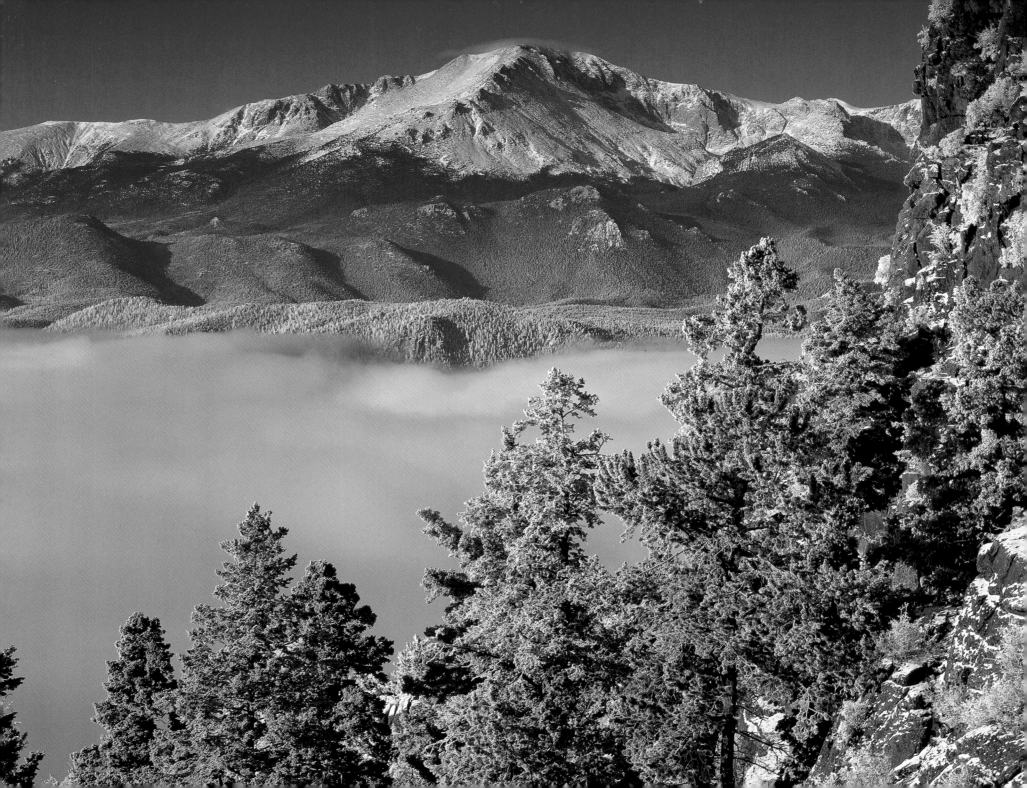

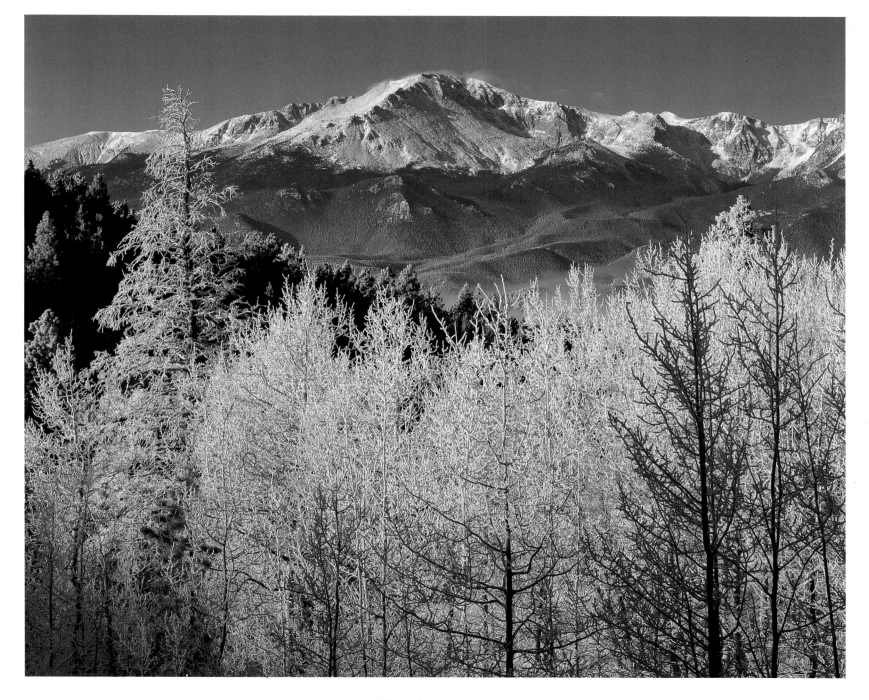

Frosted aspen grove
Left: Above the clouds

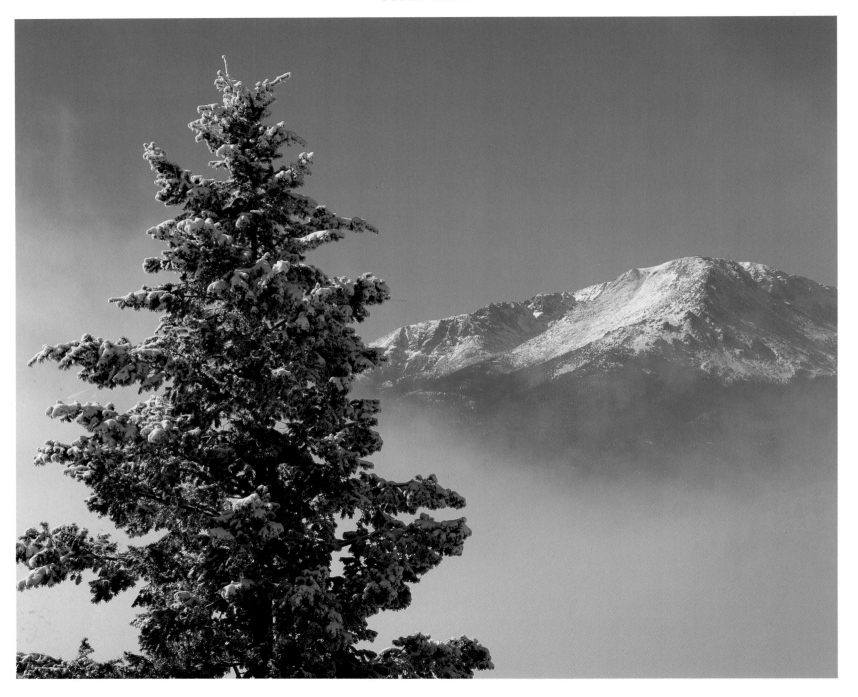

Fresh snow and fog

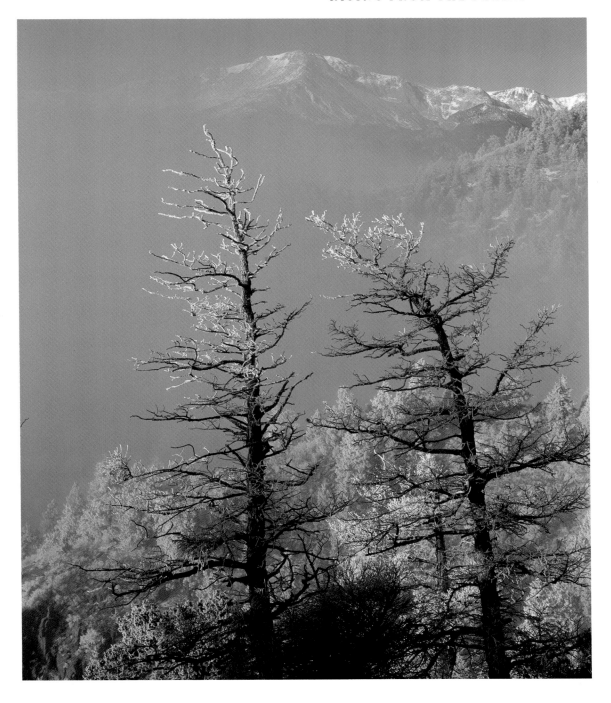

Dead trees

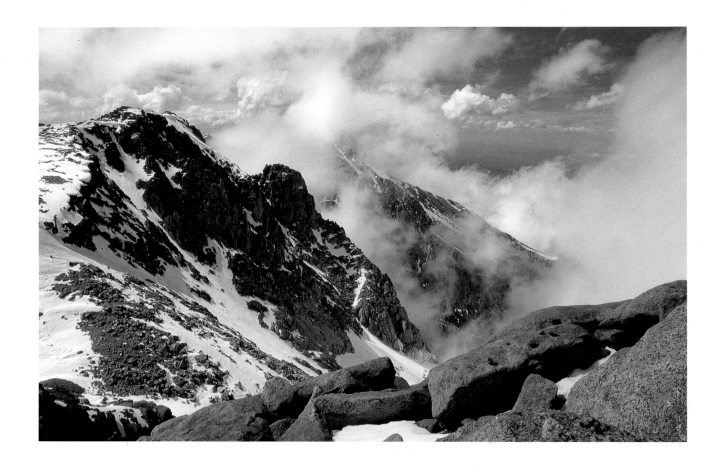

Breaking storm over the Bottomless Pit

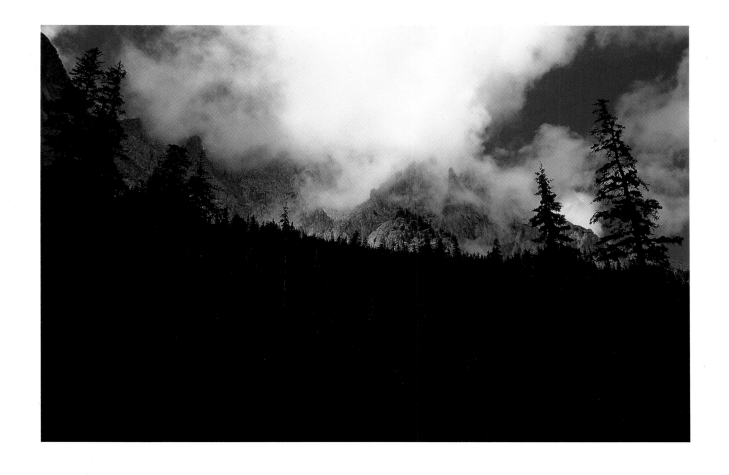

Morning clouds, Ghost Town Hollow

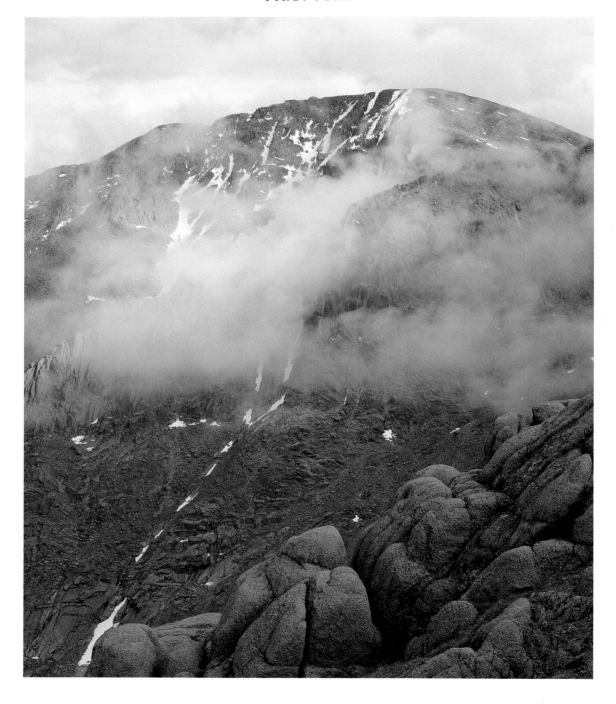

A thunderstorm's aftermath

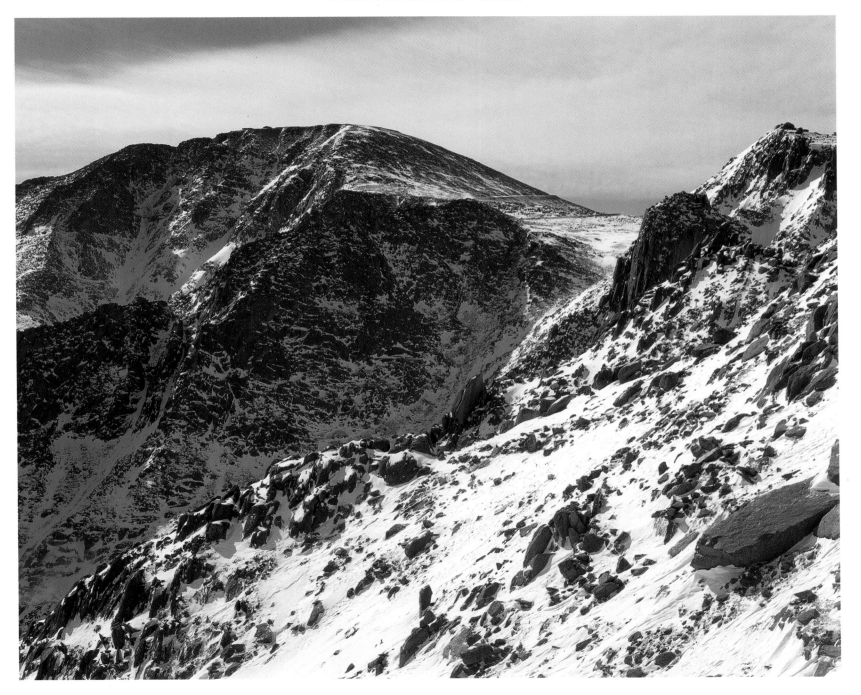

Winter view

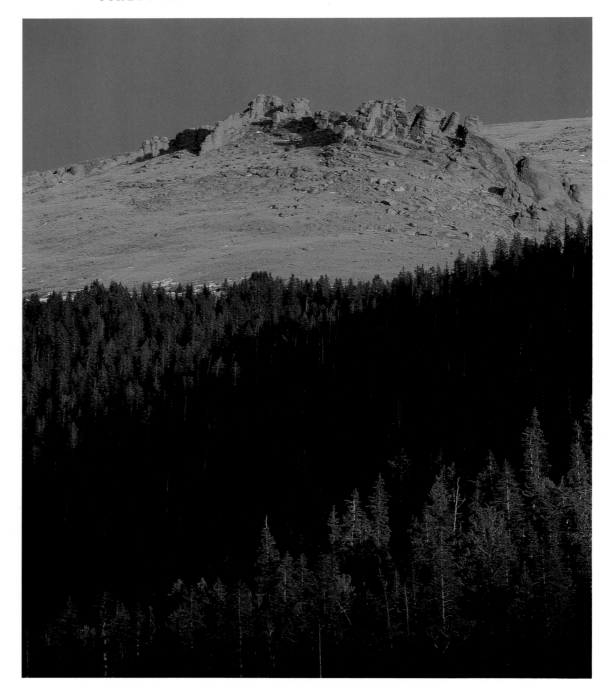

Granite knobs at sunset, on the western slopes

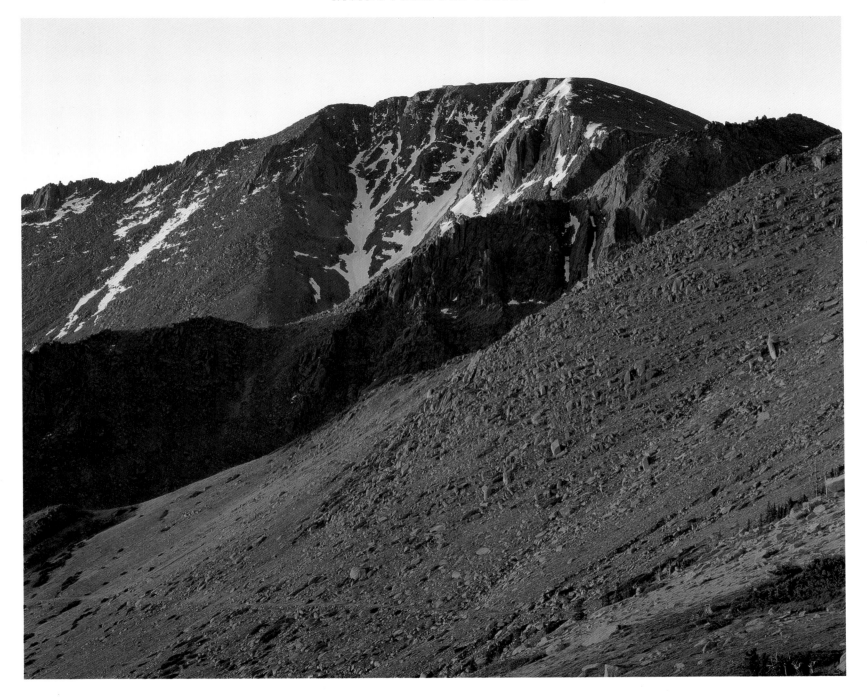

Alpenglow, the North Face
Overleaf: Cloud bank, Rampart Range

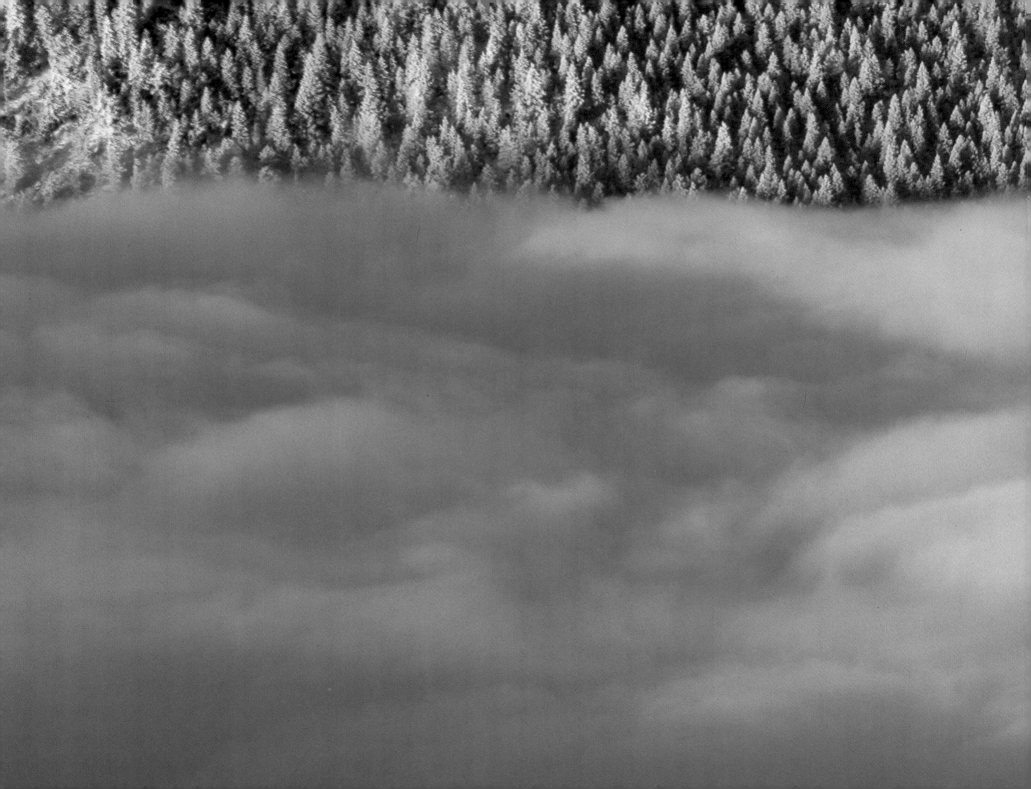

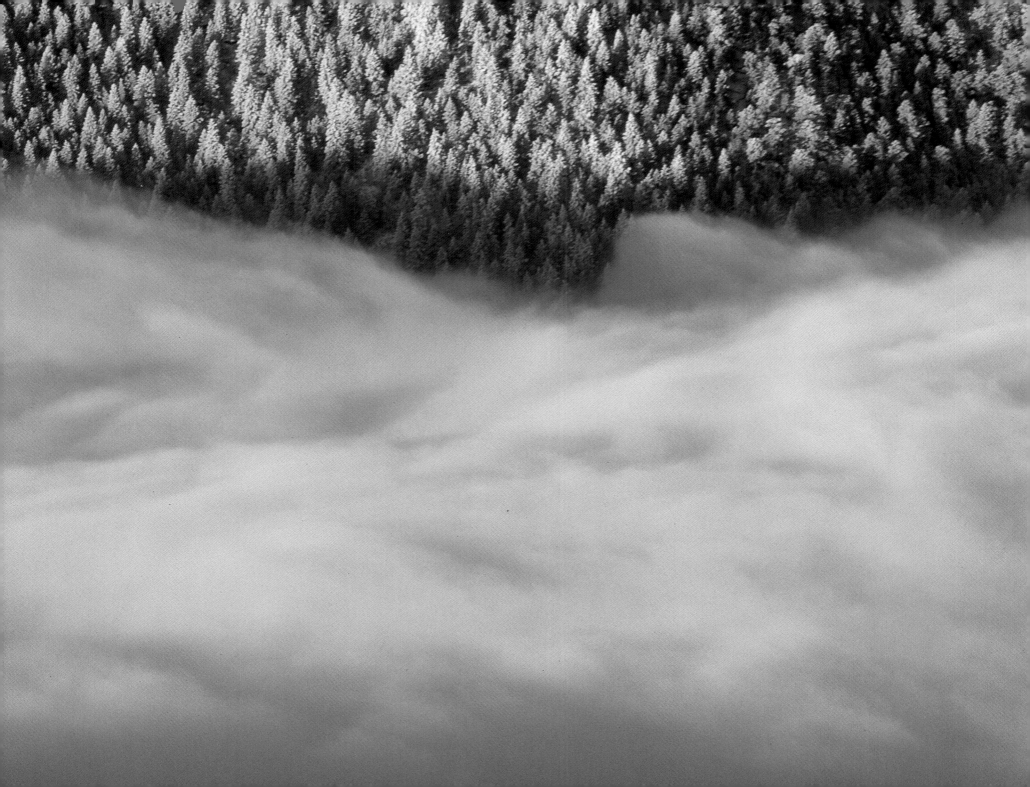

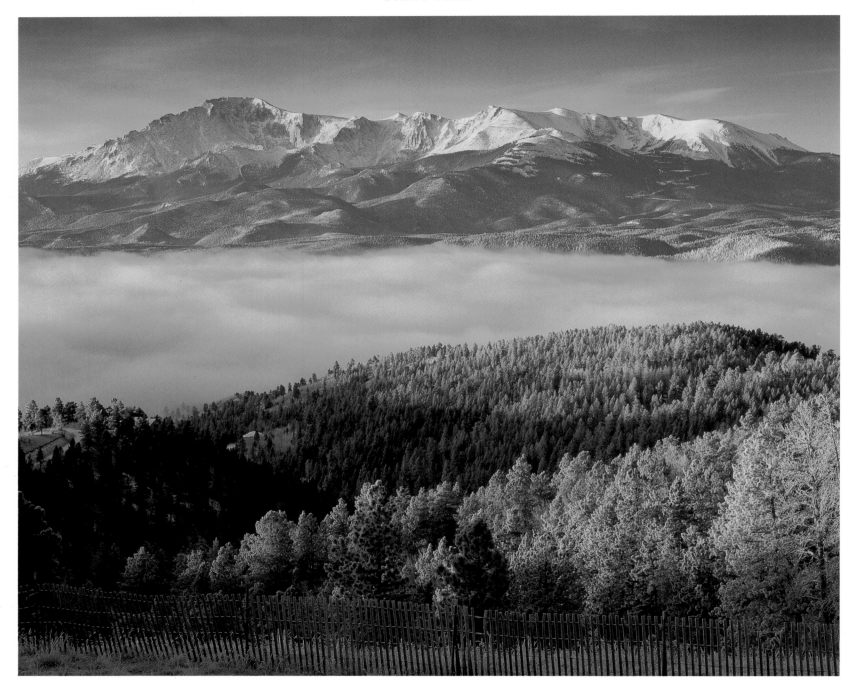

Snow fence and cloud bank
Right: The view from southern Douglas County

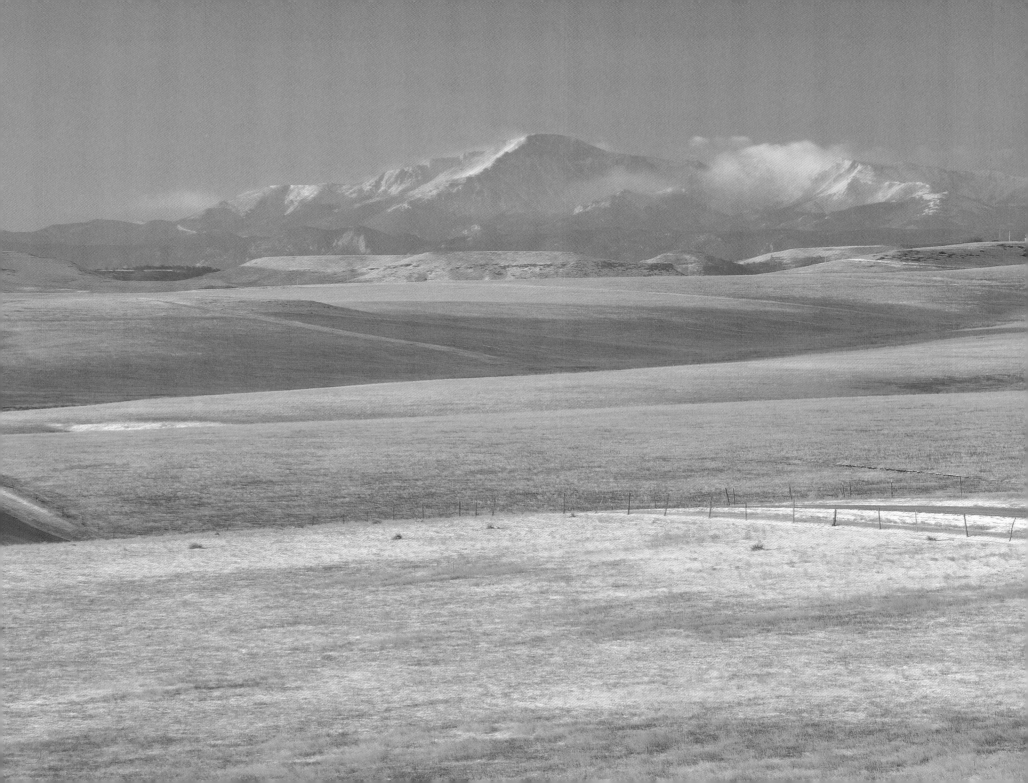

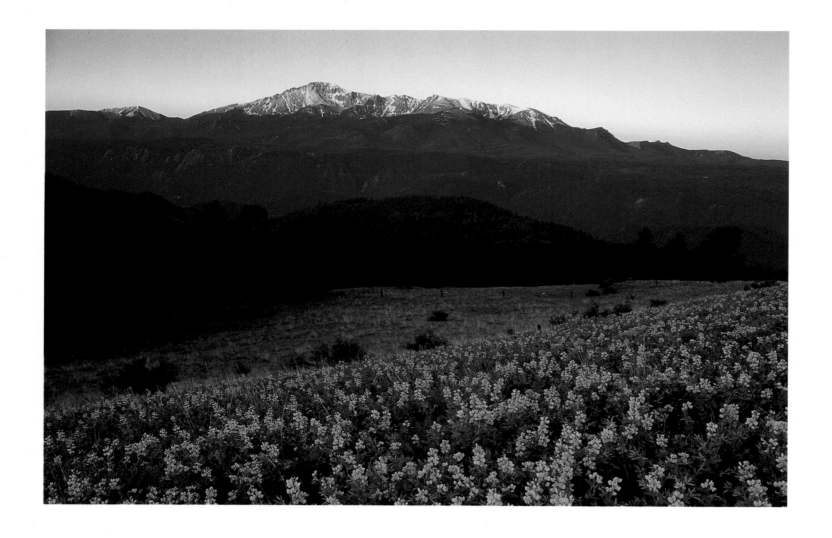

A field of golden banner

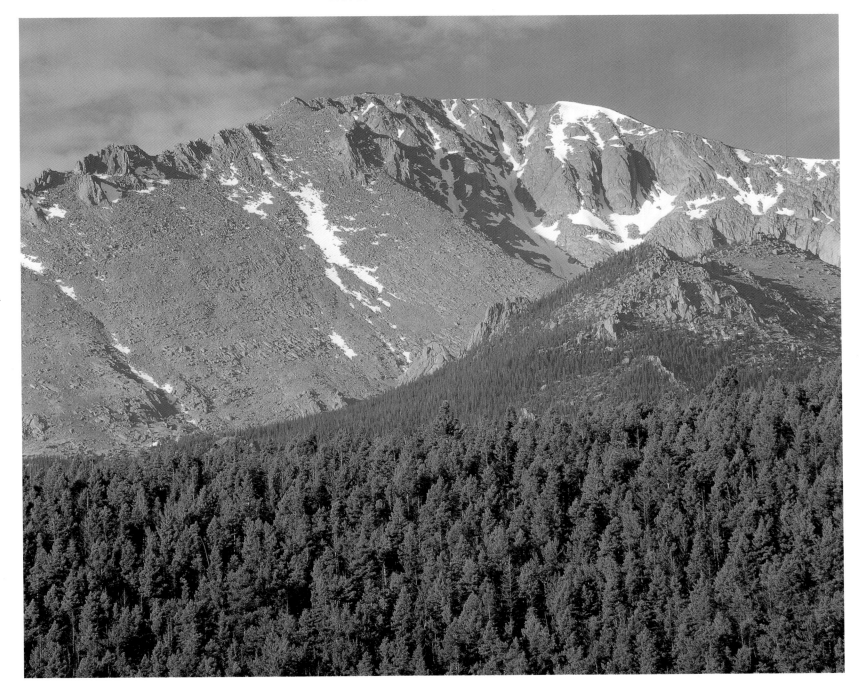

A dominating view from the Pikes Peak Highway

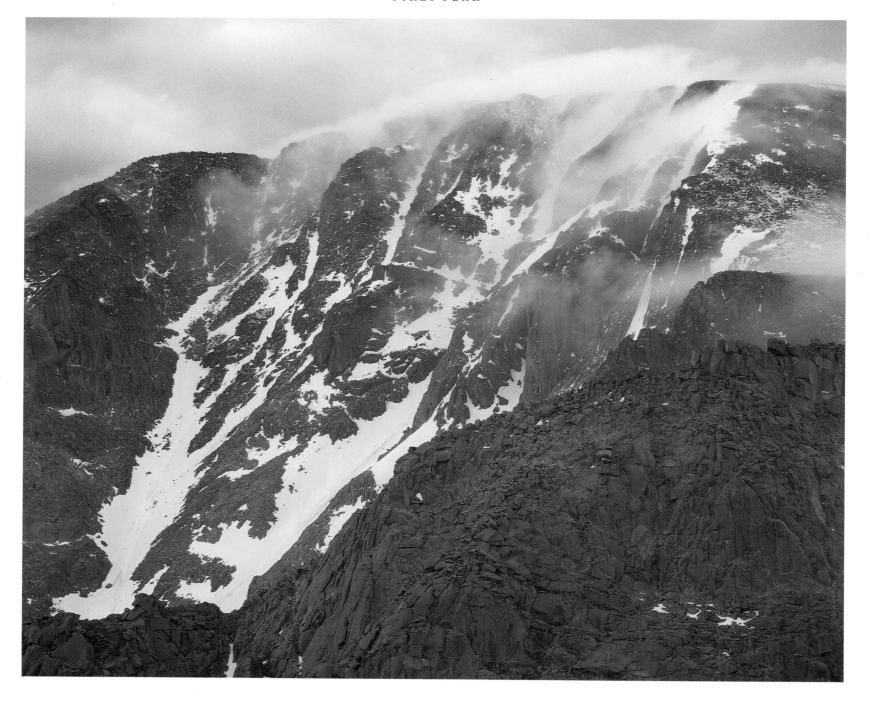

Clouds spilling into the Bottomless Pit

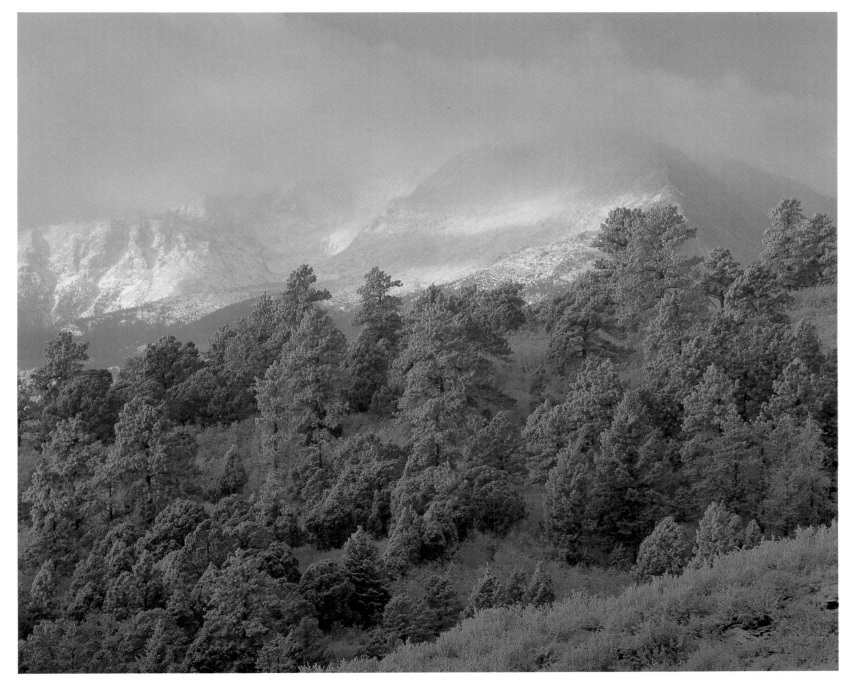

Fresh snow on Rampart Range
Overleaf: Receding ridgelines

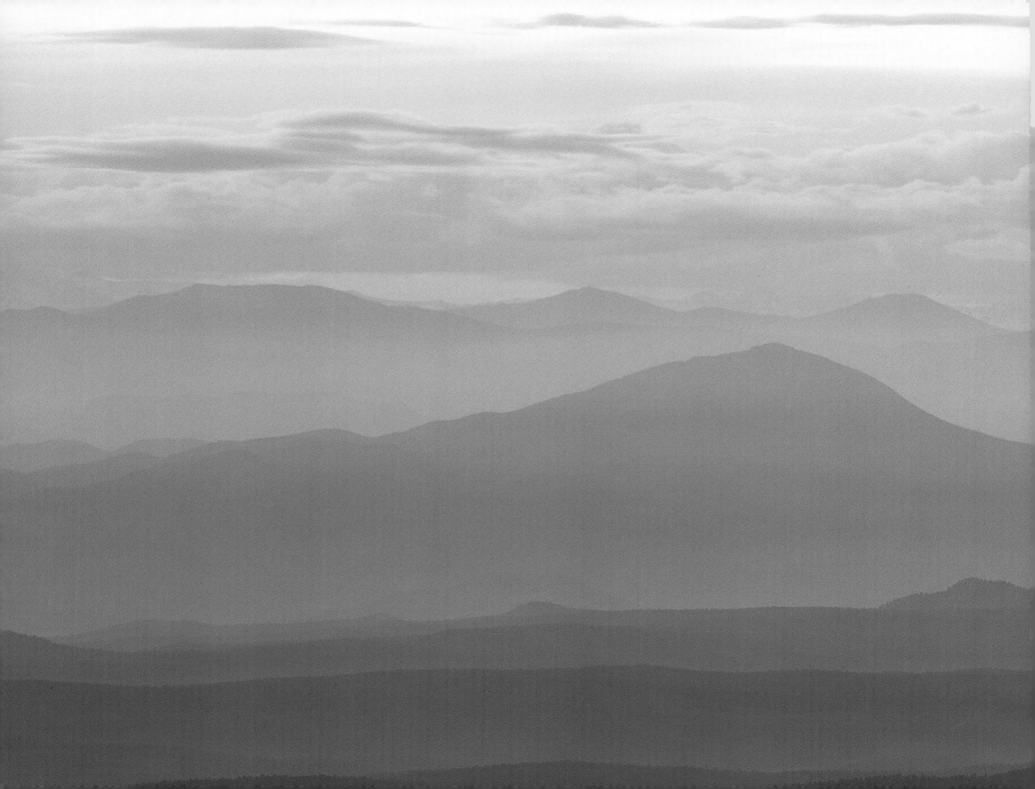

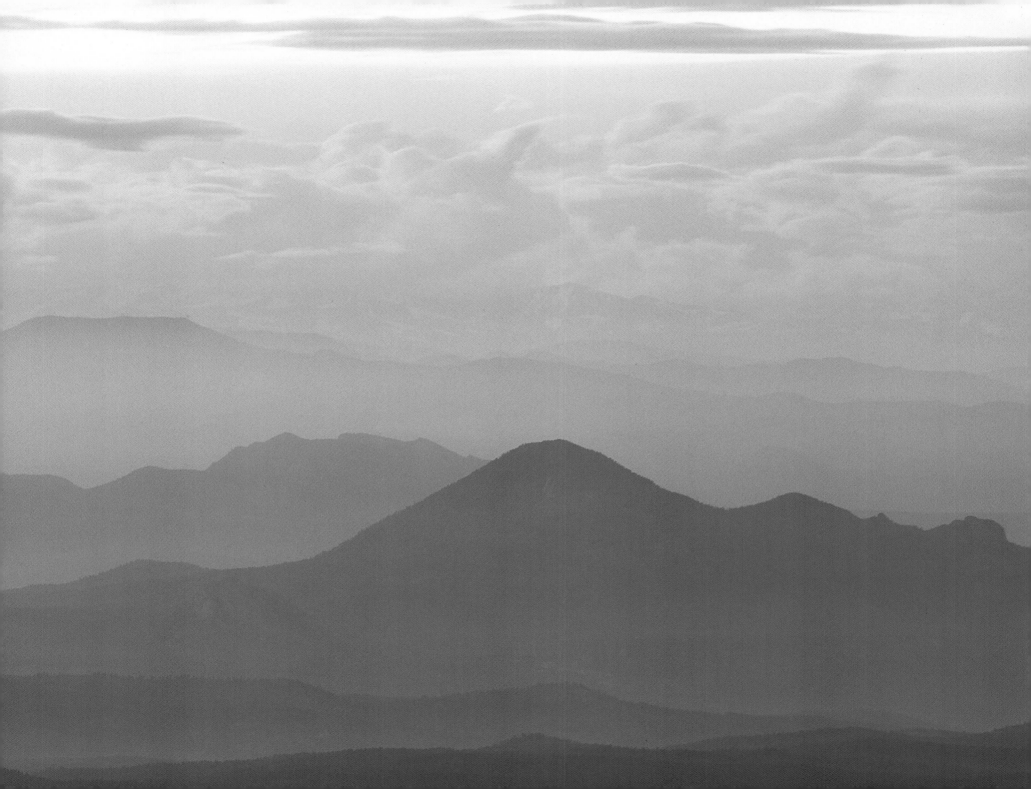

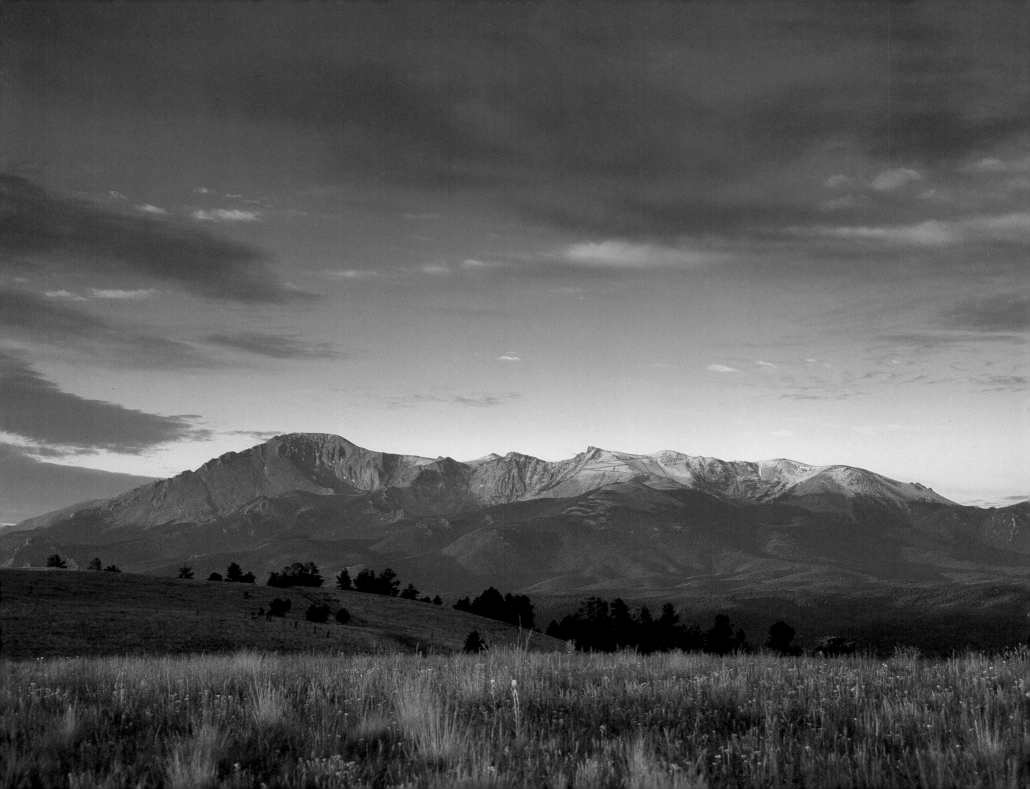

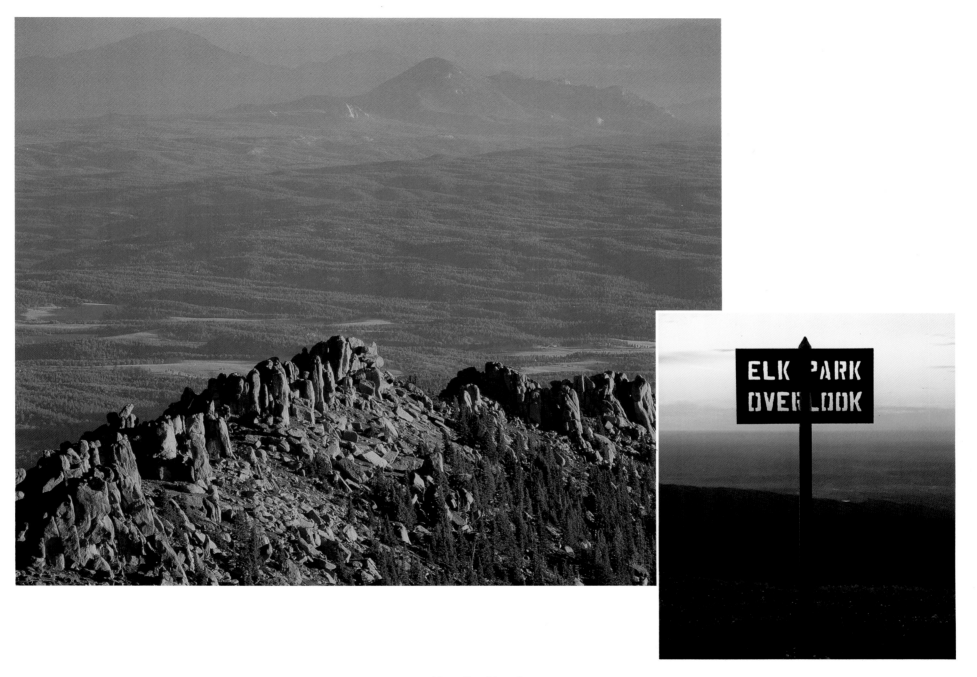

Above: Looking down
Right: Elk Park overlook
Left: Summer meadow

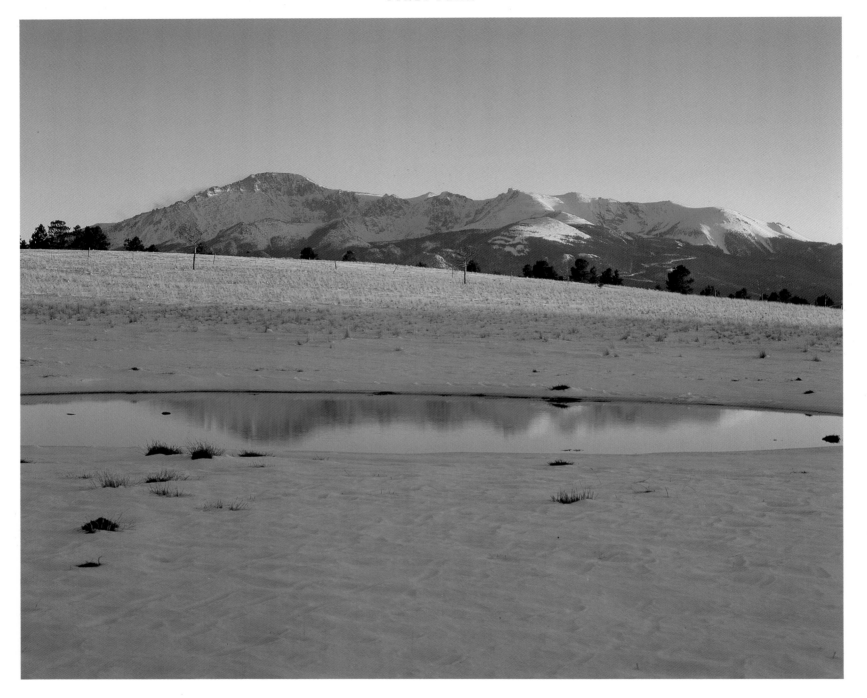

Winter reflection

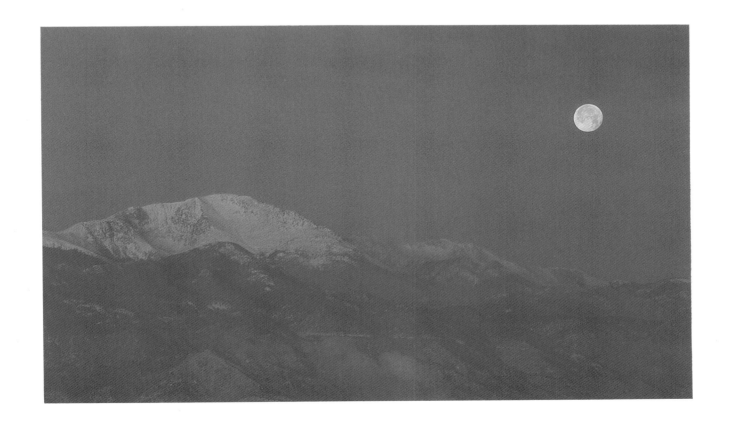

Moonset

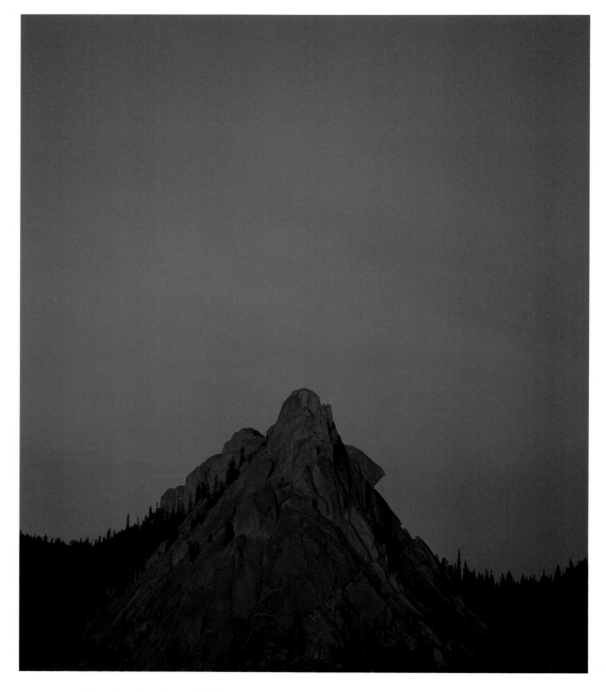

Granite spire, Crags Trail
Right: Obscured by clouds

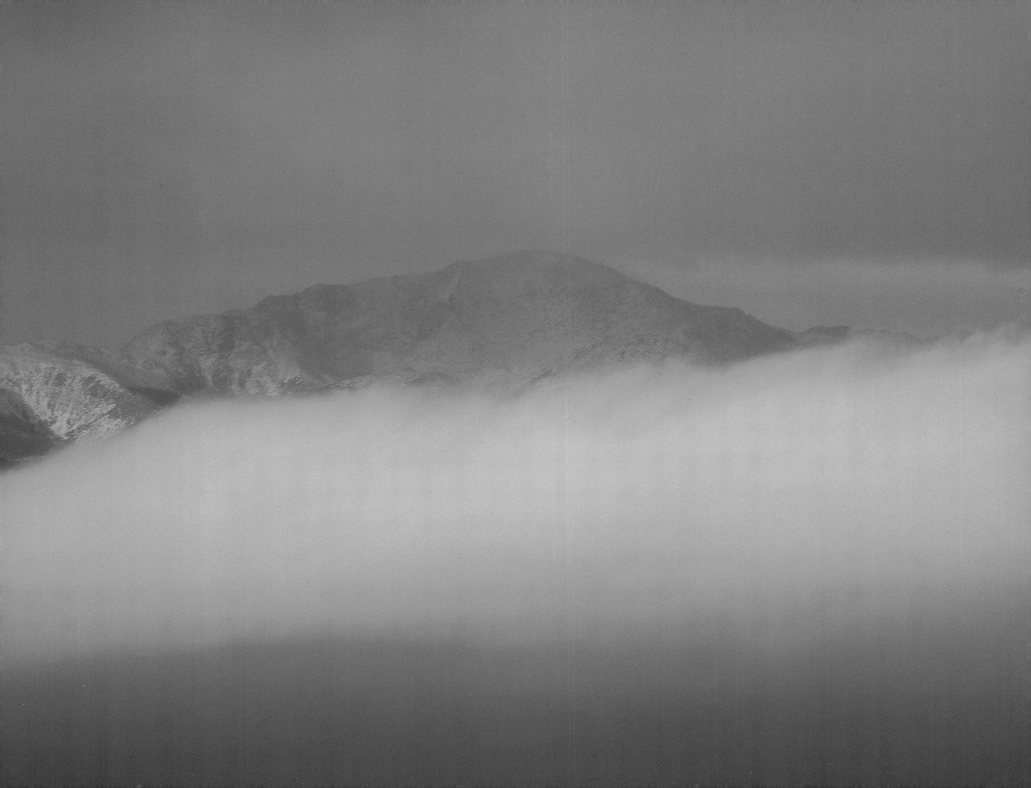

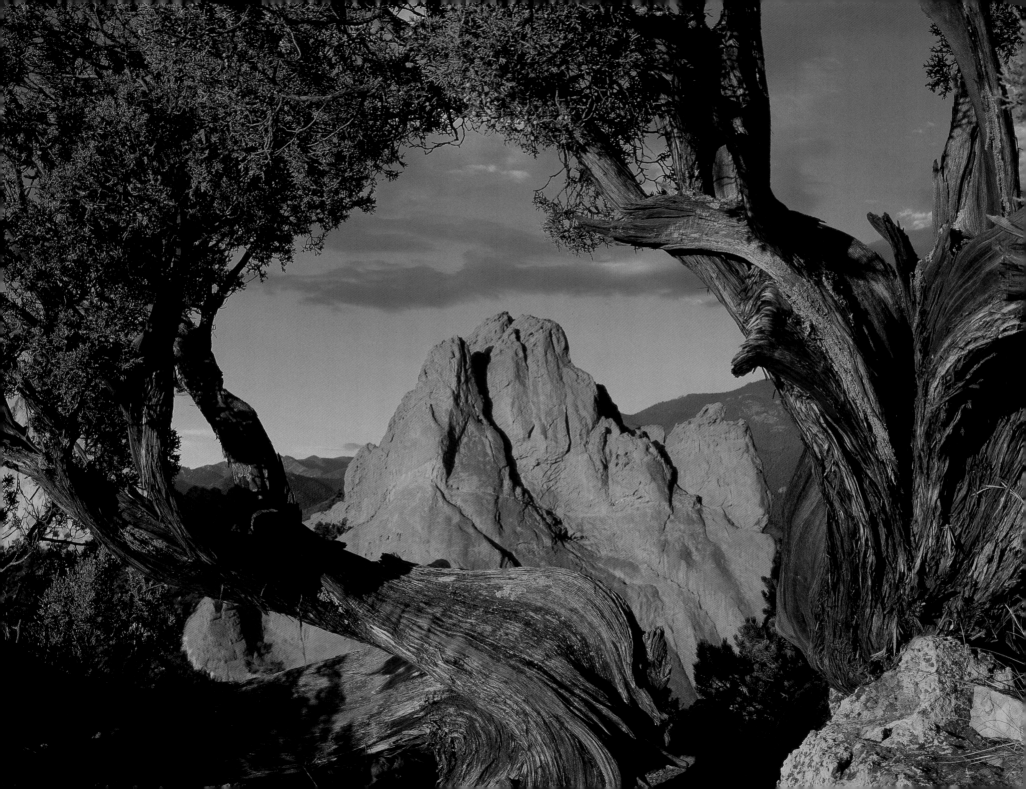

Garden of the Gods

Images in Stone

Walking through Garden of the Gods is like walking through geologic time. The rocks comprising the Garden date back to several different periods of Earth history, but most were initially laid down as sand along beaches, in riverbeds or as desert dunes.

The area we now know as Garden of the Gods was a desert environment 250 million years ago. But the Earth is not static, and environments changed. During the Cretaceous Period 110 million years ago, Tyrannosaurus rex roamed the land, and the Pikes Peak region was under a vast inland sea. Sand deposits on the sea floor turned to sandstone once the seas retreated. Several million years passed, and the sandstone layers were buried under more recent rock layers. It took the massive forces that created the Rocky Mountains to once again expose the sea beds and sand dunes of the past. The Pikes Peak Uplift, which created the huge Pikes Peak batholith about 65 million years ago, caused the underlying layers of granite to thrust upward, turning the upper layers of sandstone on their sides. Millions of years of wind, water and frost erosion shaped the sandstone fins into the familiar forms we see today.

In geologic terms, man's presence in the Garden is a mere blink of an eye. Evidence indicates humans inhabited the Garden of the Gods more than 3,000 years ago. In more recent times, the Ute Indians lived in the area, and frequented the nearby mineral springs in what is now Manitou Springs. Other Native Americans, such as the Comanche, Cheyenne and Arapaho, visited the area as well.

After General William Palmer founded the city of Colorado Springs in the late 1800s, his friend Charles Elliot Perkins purchased a 480-acre parcel of land just south of Palmer's Glen Eyrie residence. That parcel contained the heart of today's Garden of the Gods Park. Realizing the area residents' fondness for the fantastic rock formations, Perkins treated the land like a park, allowing visitors to explore the beauty of his parcel.

Perkins died in 1907. Two years later, his children upheld his dream and donated the land to the city of Colorado Springs, with the provision that it remain "forever free" for the people of the region, and indeed the world, to enjoy.

Over the years additional parcels of land have been acquired. Today the Garden of the Gods Park covers 1,370 acres.

In 1995 the city undertook a new master plan for the Garden of the Gods. The idea was to restore much of the park to its natural balance. Some roads were eliminated, and remaining roads were configured to ease congestion within the park. Buildings were either razed or abandoned, and a new visitors' and interpretive center was built just outside the park's boundary. Today a visit to Garden of the Gods is more like visiting it in the day when the Utes walked the land. The deer and the coyote have reclaimed this beautiful garden of stone. Nature is once again caretaker of this incredible domain.

Sandstone waterpocket
Left: One-seed juniper and South Gateway Rock

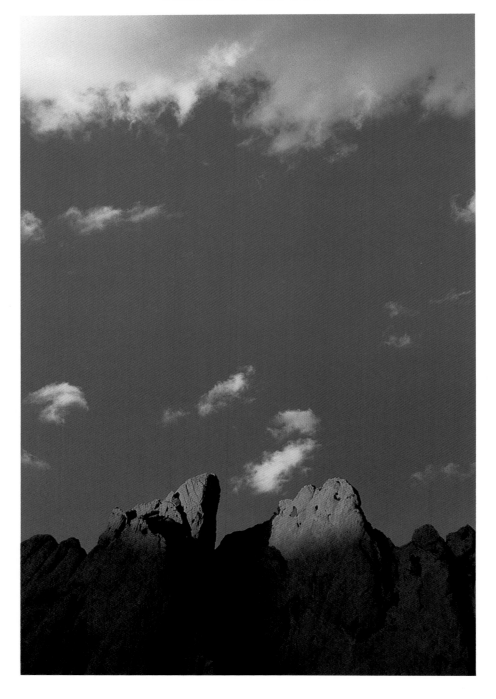

Clouds and Kissing Camels

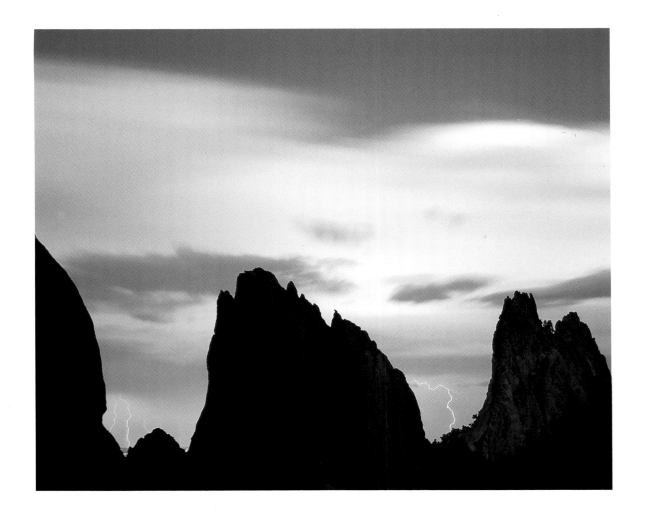

Lightning storm

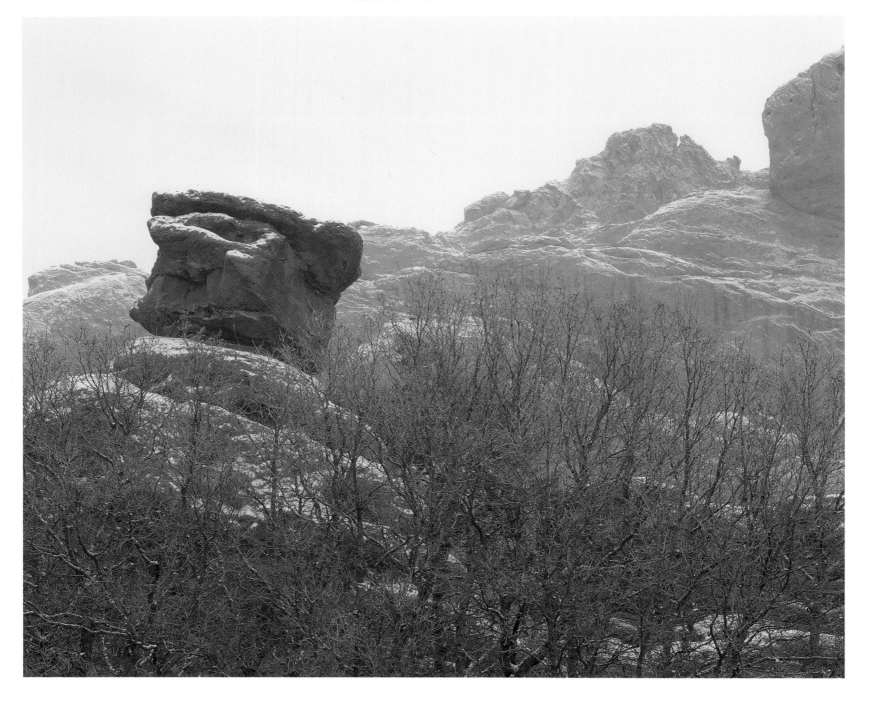

The Scotsman in winter

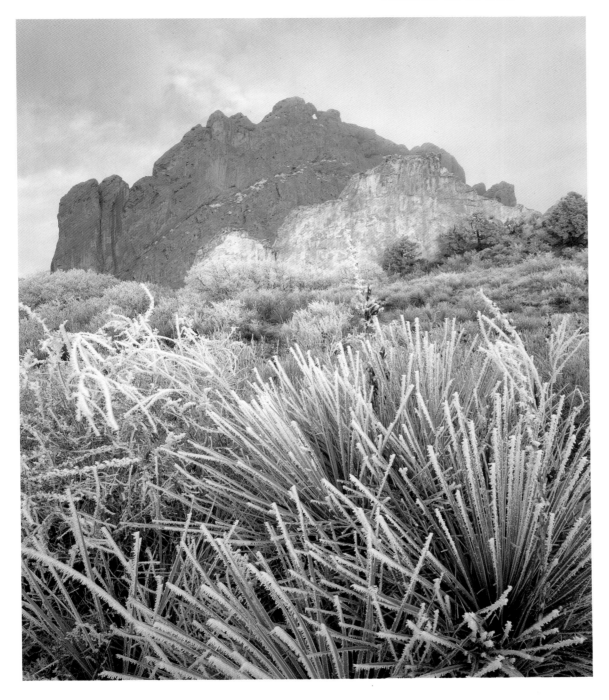

Rime ice and yuccas

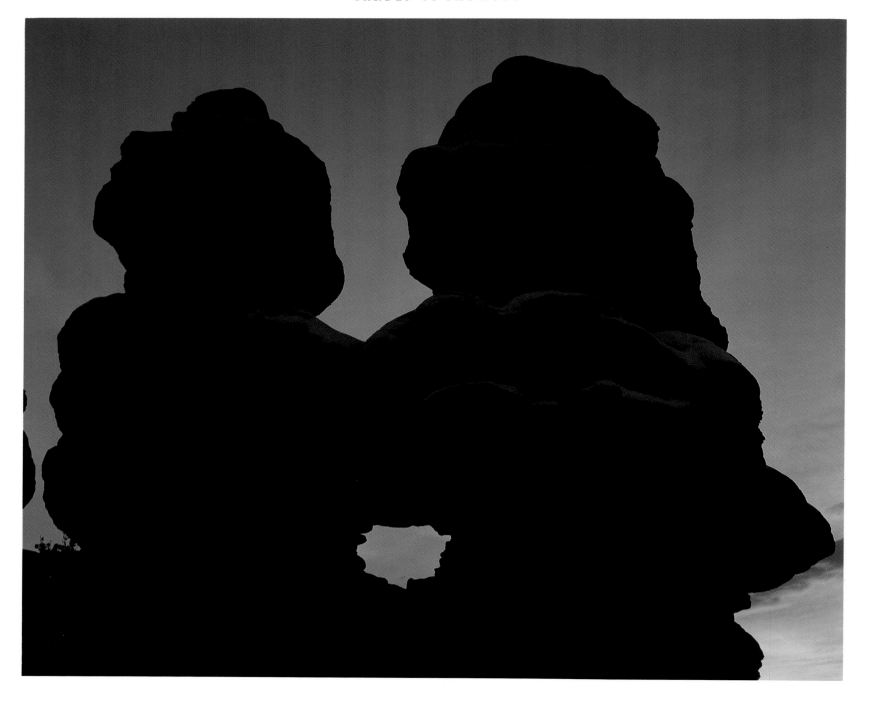

Siamese Twins at dawn

Unnamed arch and Kissing Camels

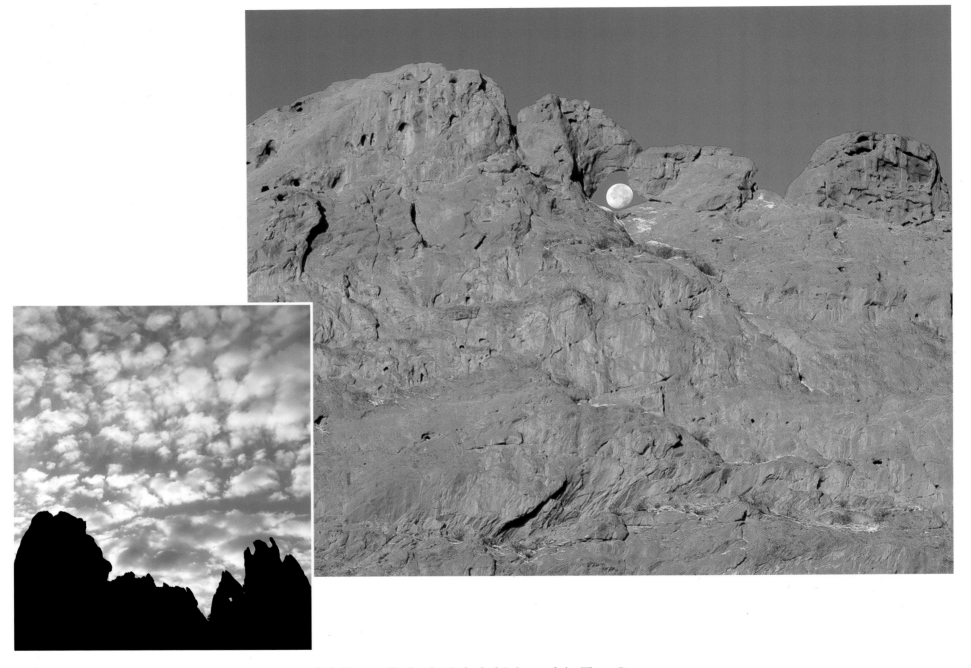

Left: Buttermilk clouds, Cathedral Spires and the Three Graces
Above: Waning full moon and Kissing Camels
Right: Crescent moon and Kissing Camels

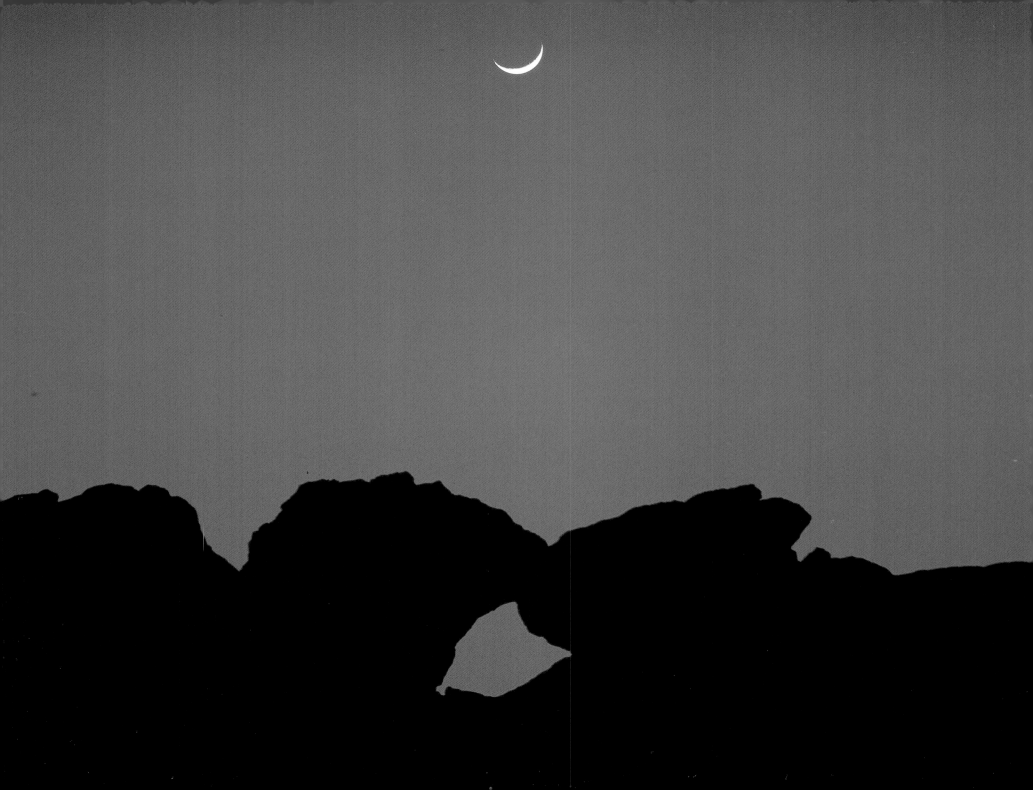

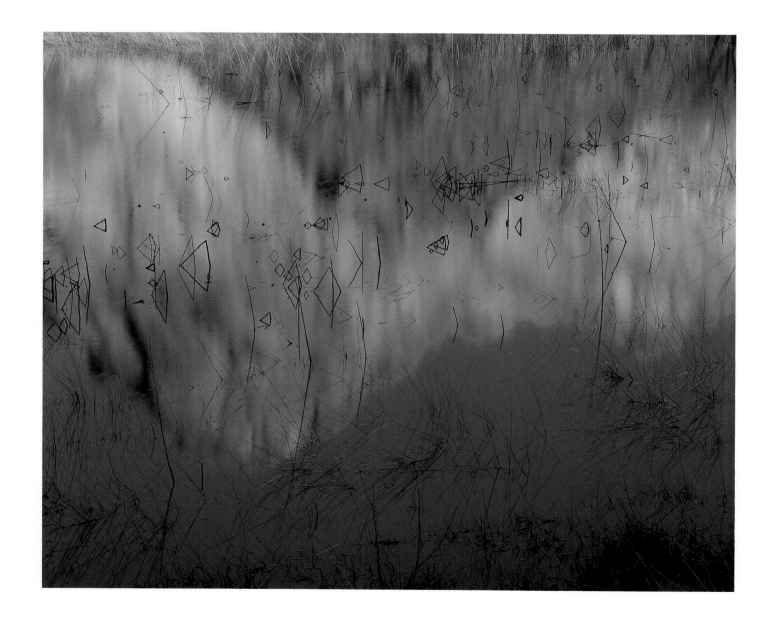

Reflection detail

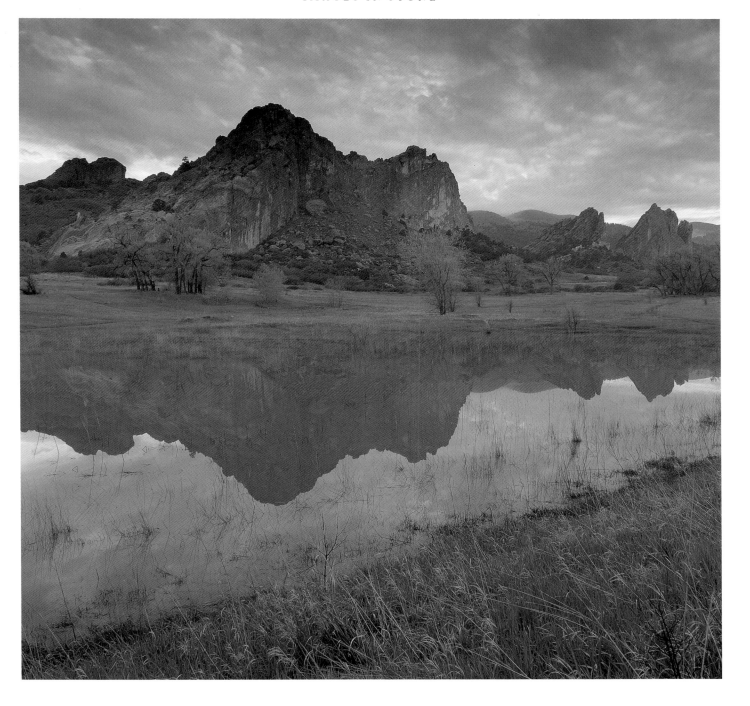

Silt-laden pond

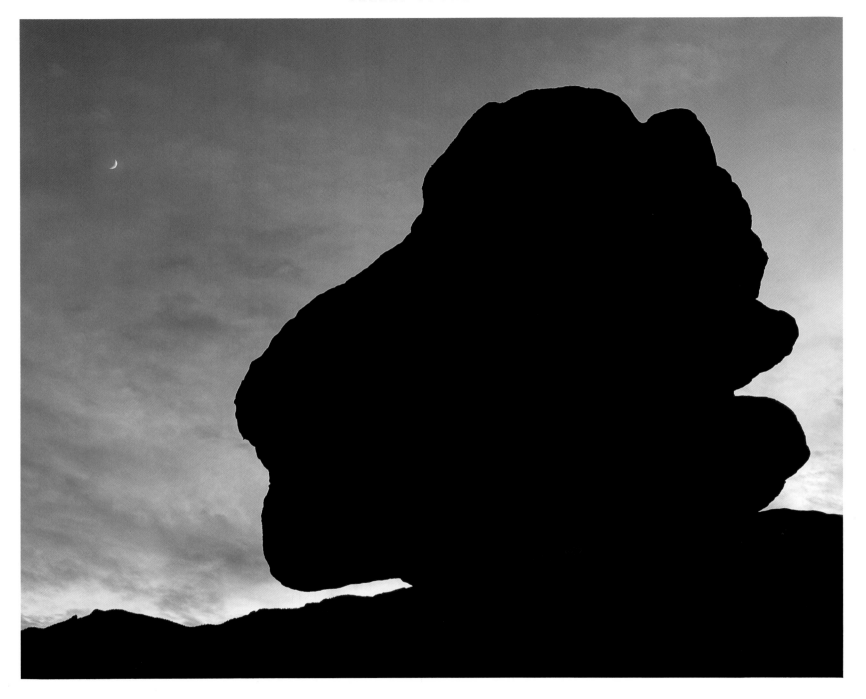

Balanced Rock and crescent moon

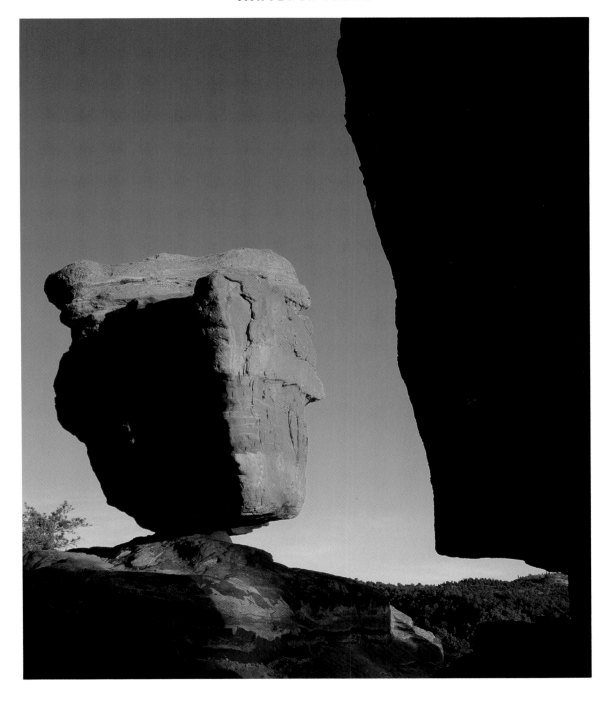

Sunrise, Balanced Rock

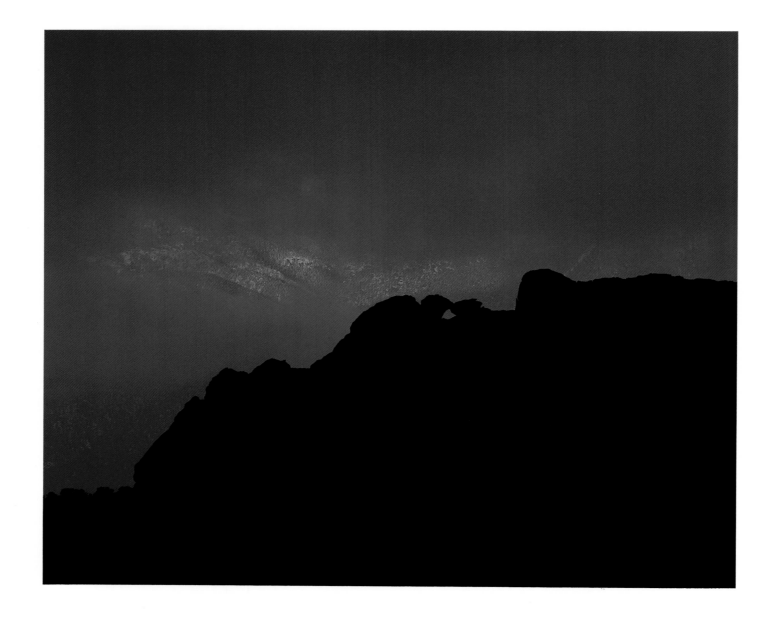

Kissing Camels and approaching storm clouds

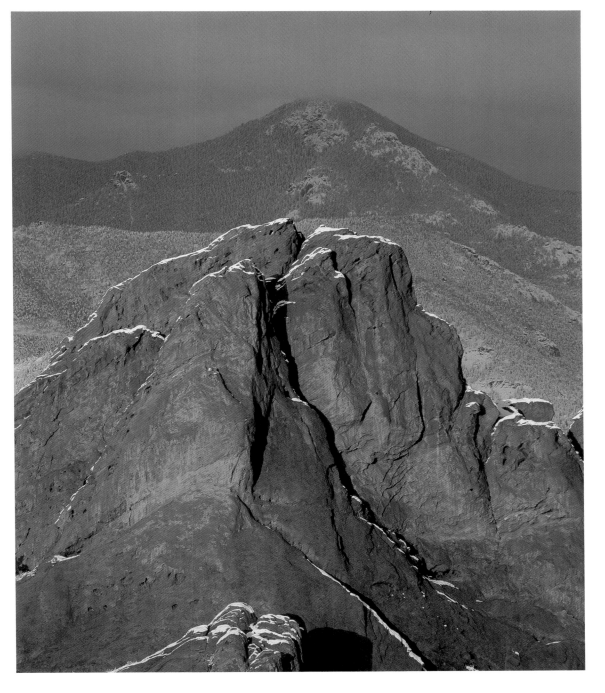

Camerons Cone and South Gateway Rock
Overleaf: Sunset skies and silhouettes

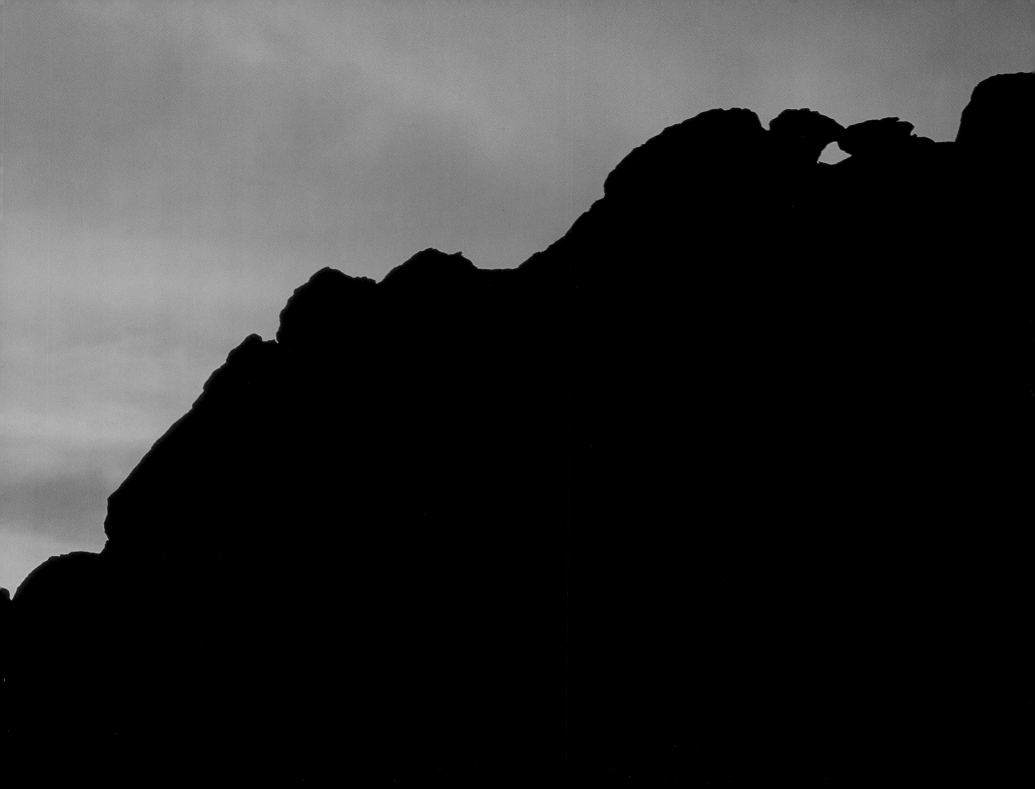

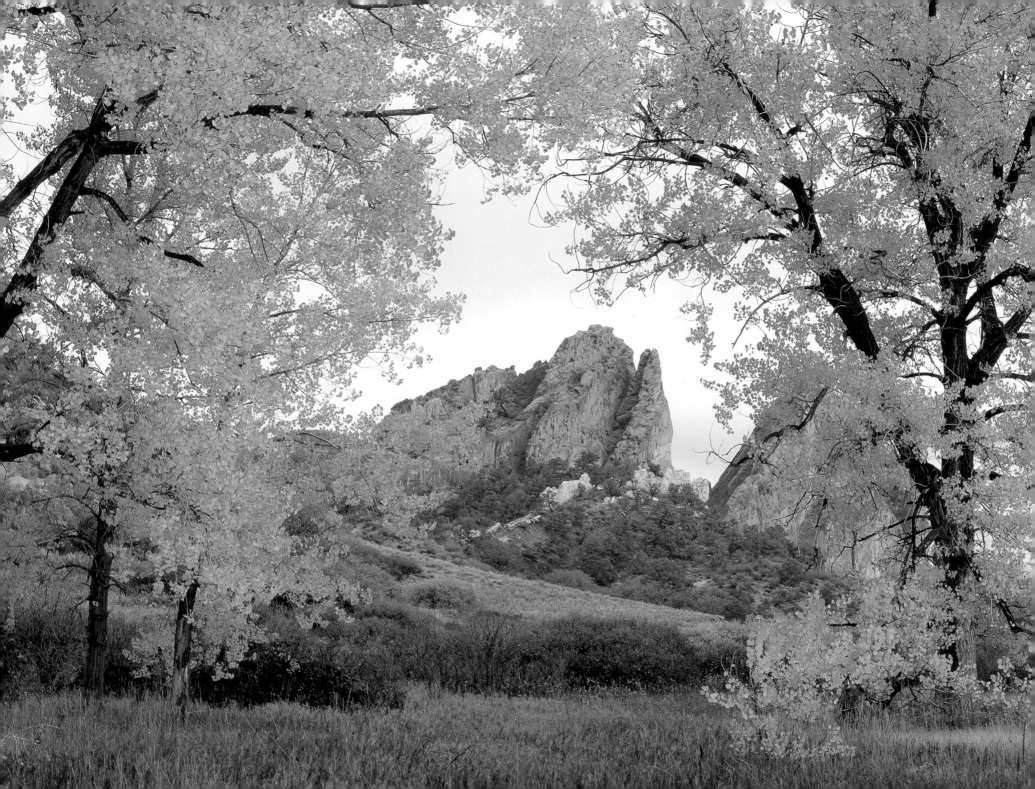

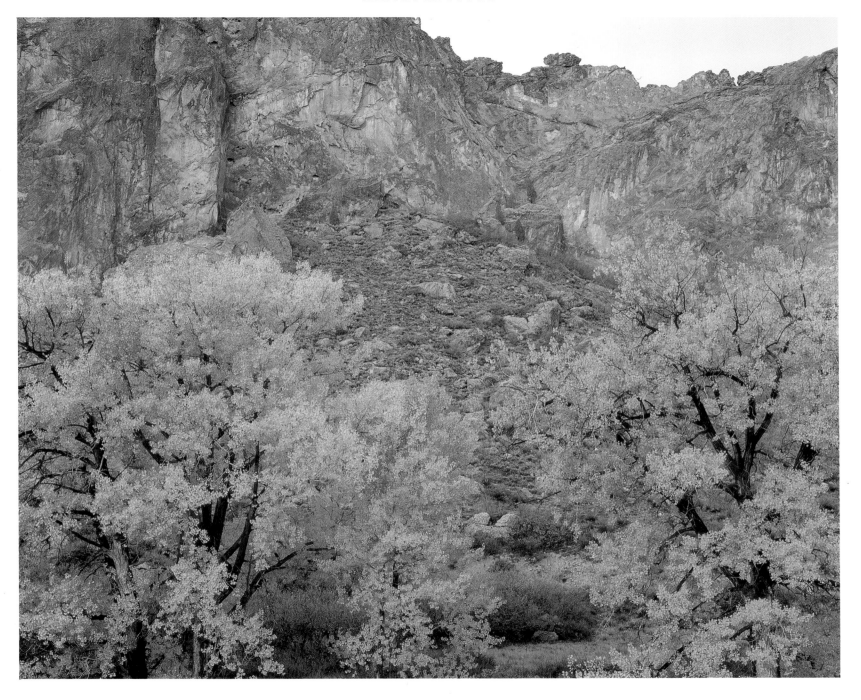

Autumn cottonwoods, South Gateway Rock *(left)* and Cathedral Rock *(above)*

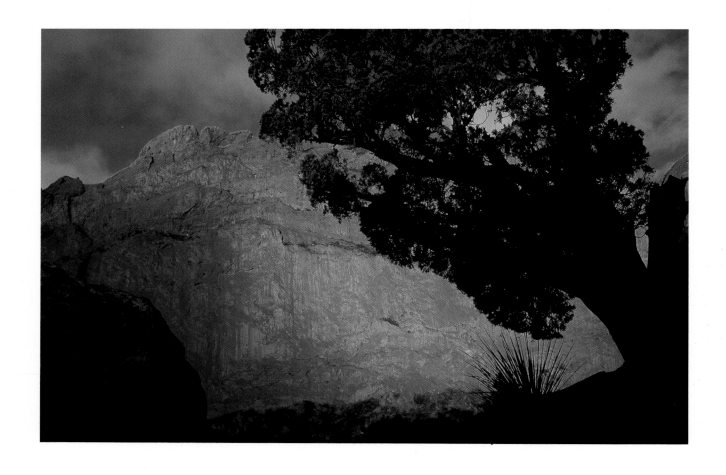

Morning light, Kissing Camels

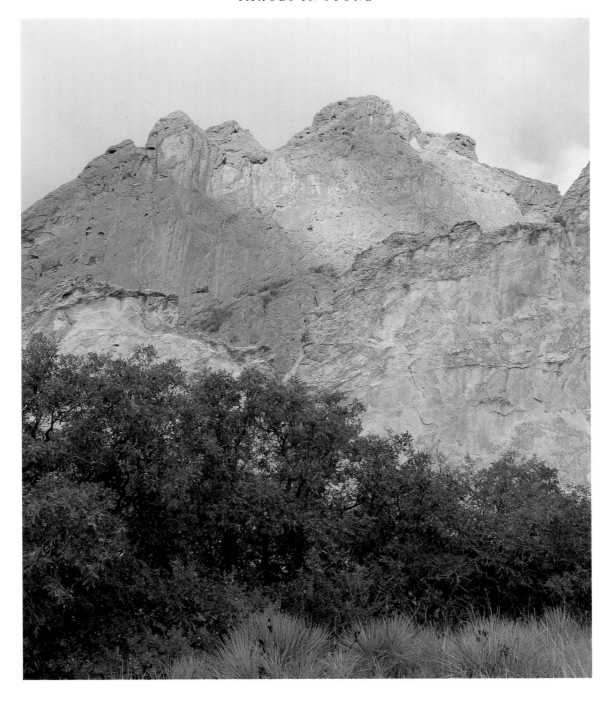

Summer greenery

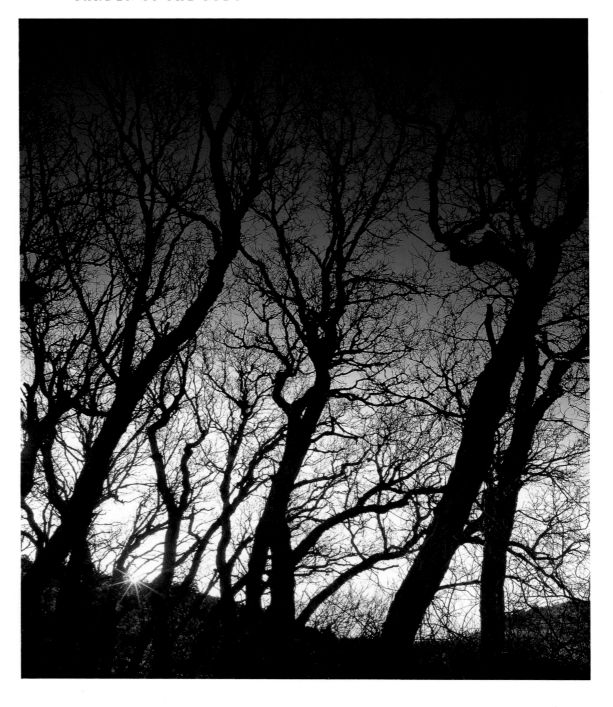

Sunburst through barren oak

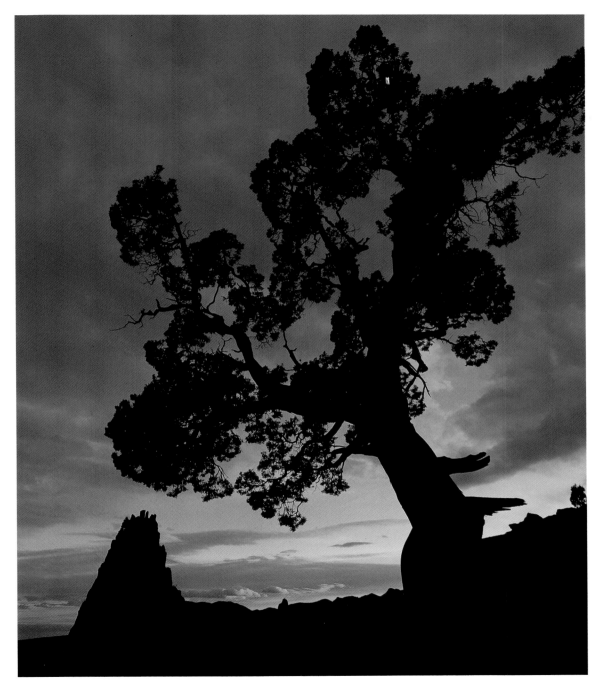

Juniper tree and Cathedral Rock
Overleaf: After the storm

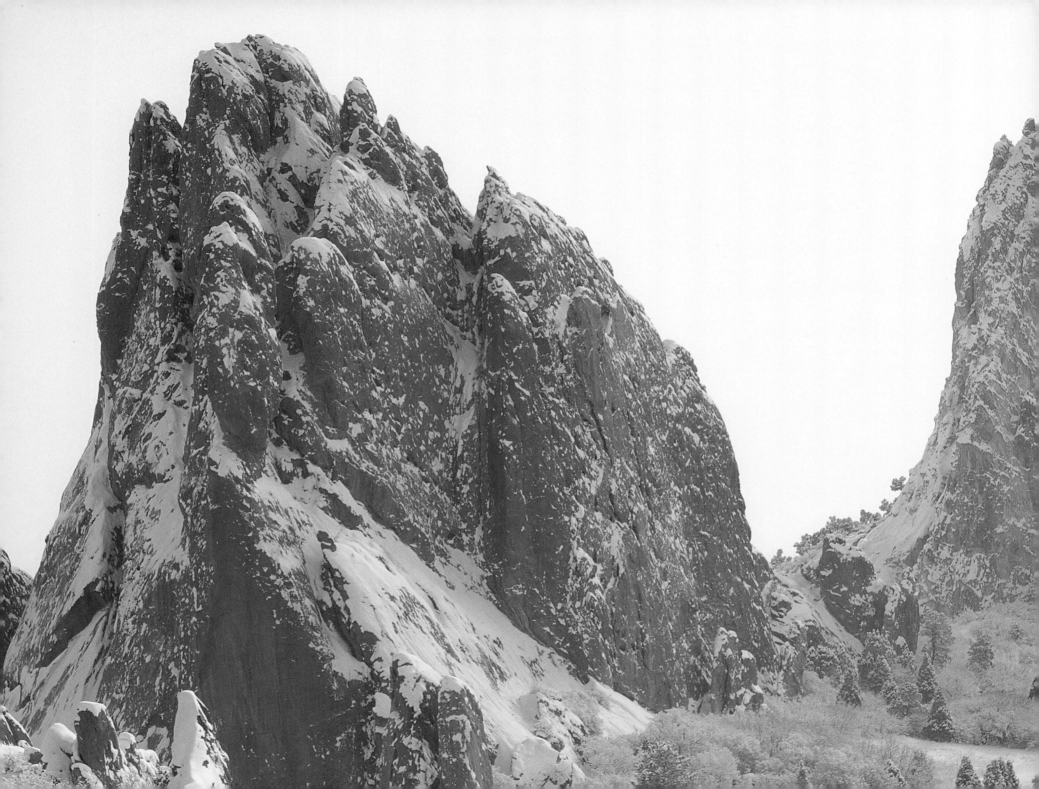

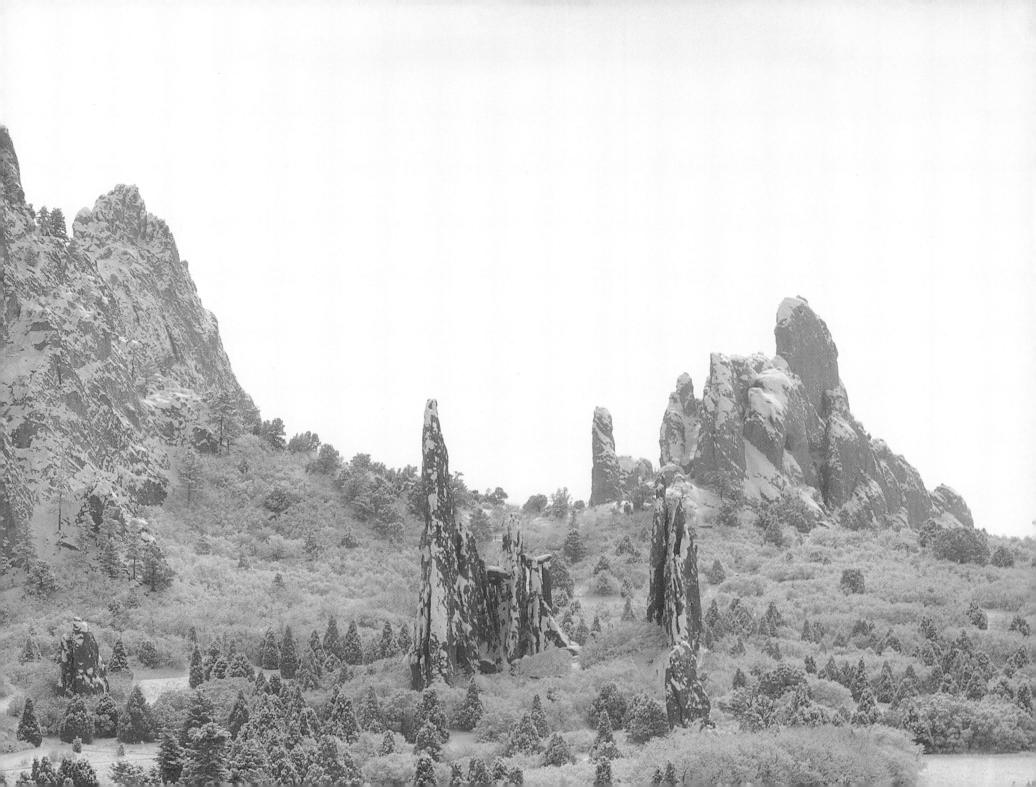

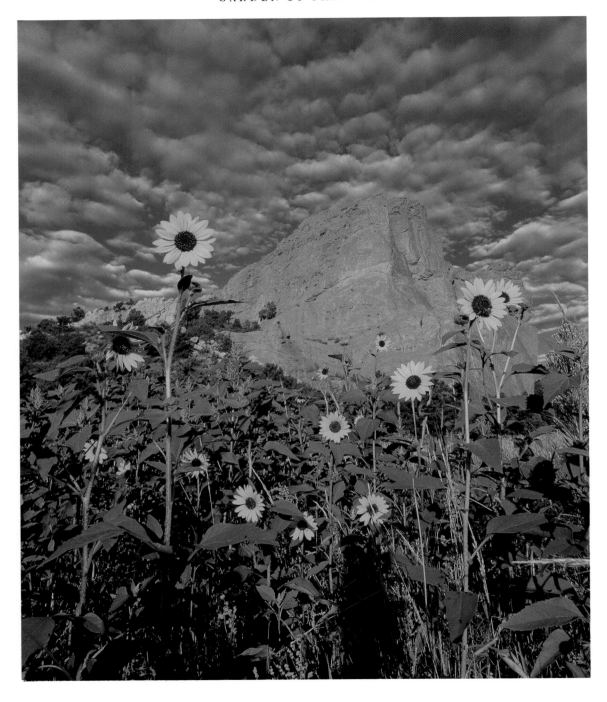

Sunflowers, South Gateway Rock

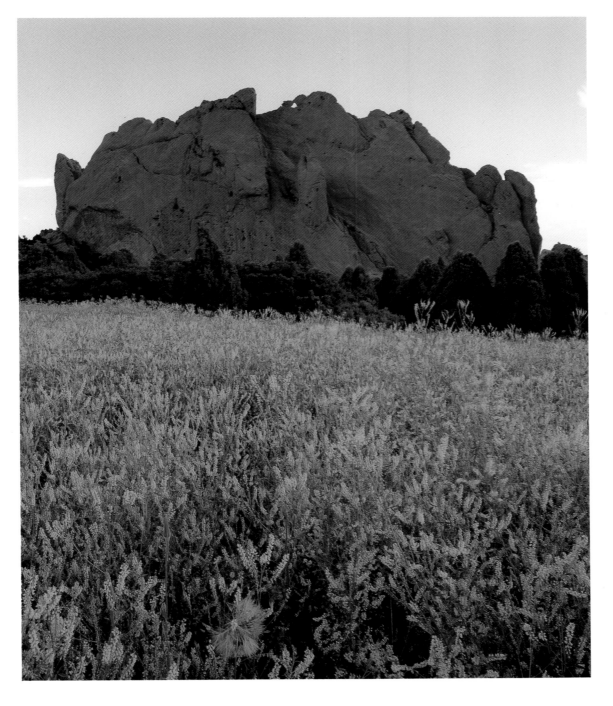

Field of yellow, Kissing Camels

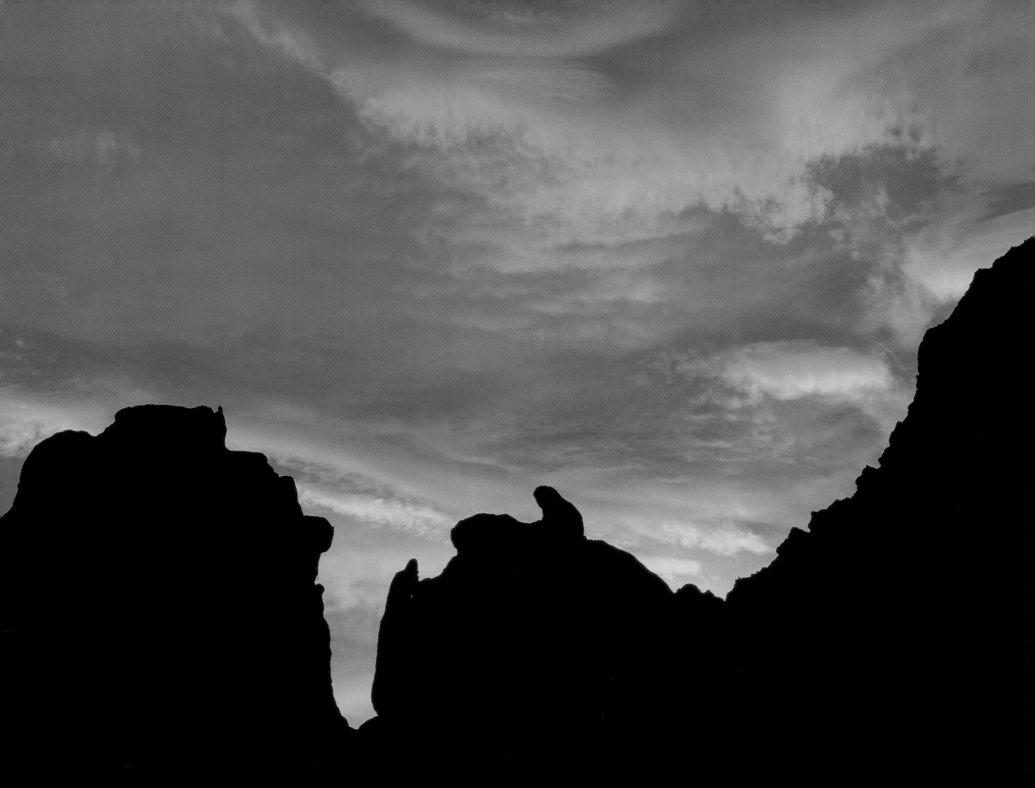

Sandstone detail, Cathedral Spires
Left: Sunrise colors, Cathedral Spires and the Three Graces

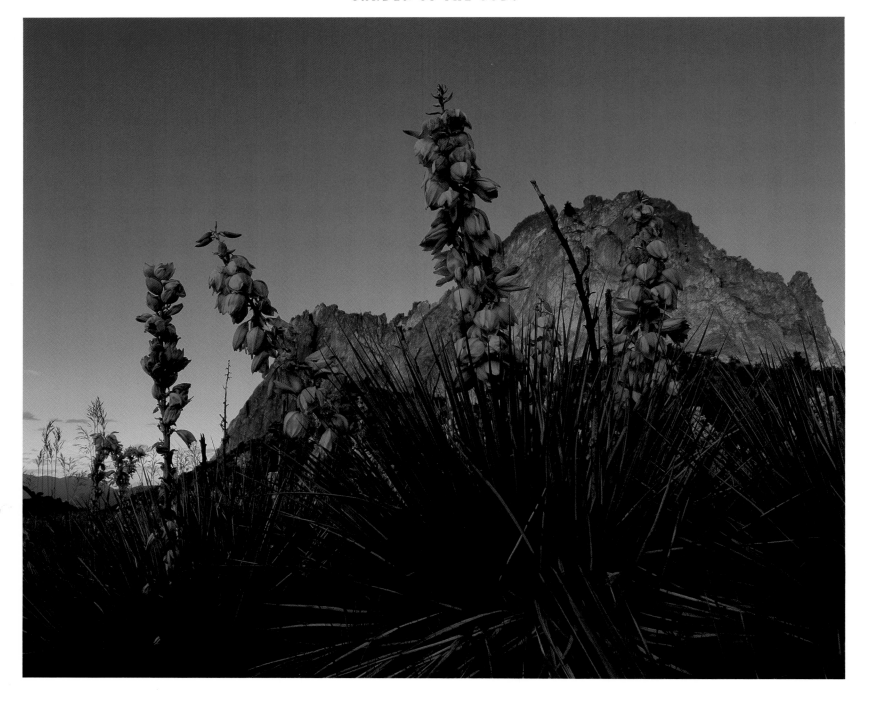

Yuccas with seed pods and Cathedral Rock

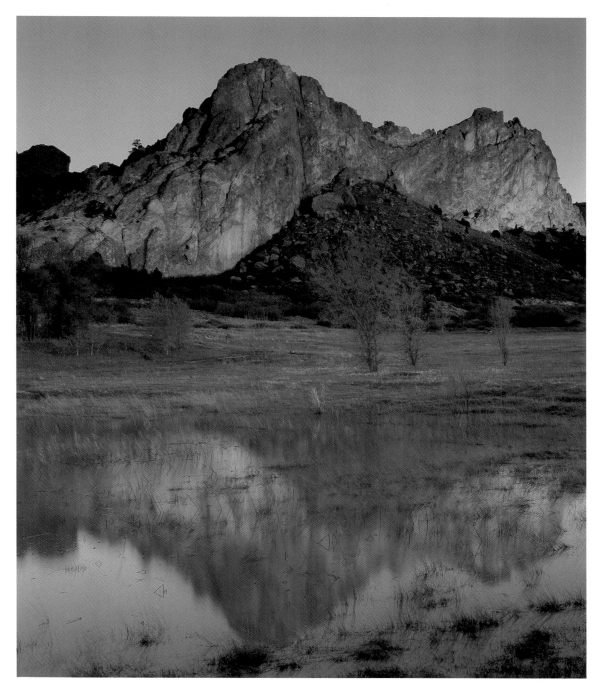

Cathedral Rock reflection
Overleaf: Moonset, Tower of Babel

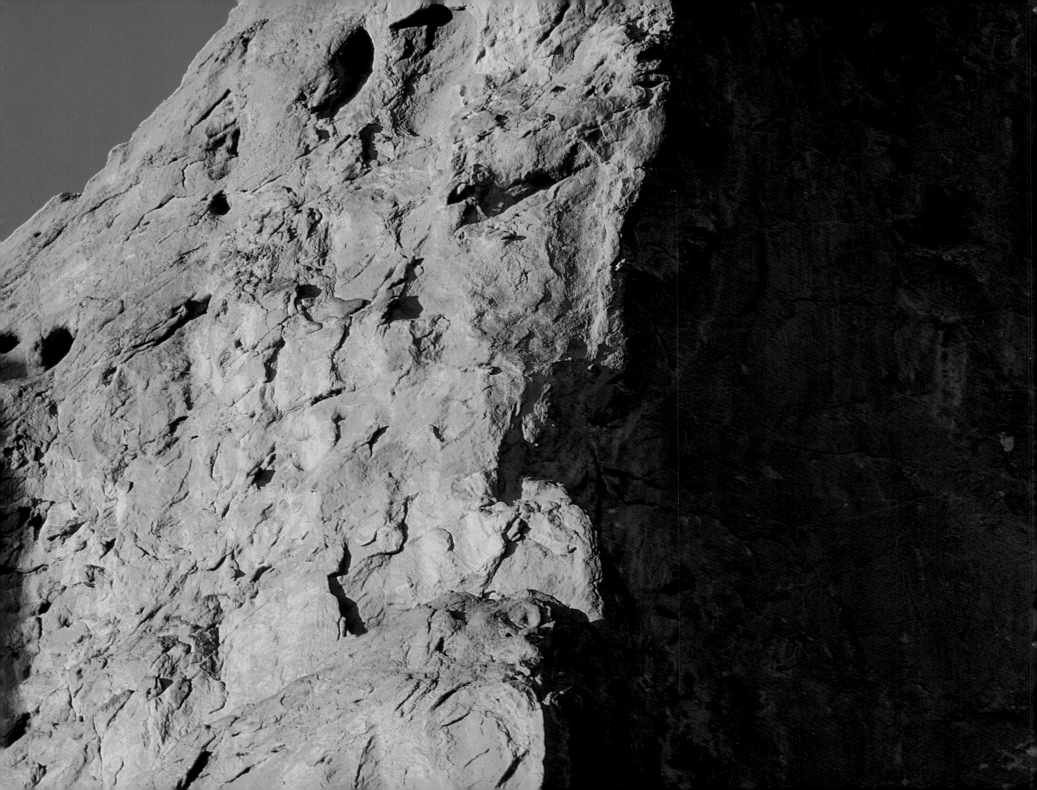

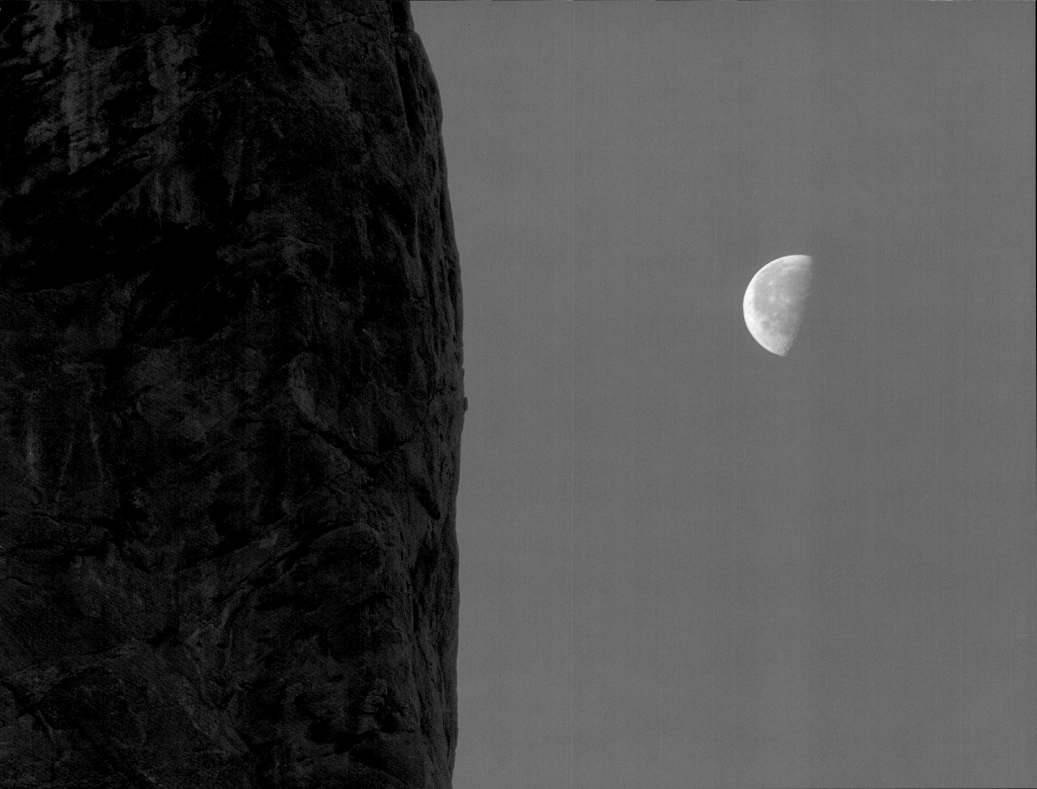

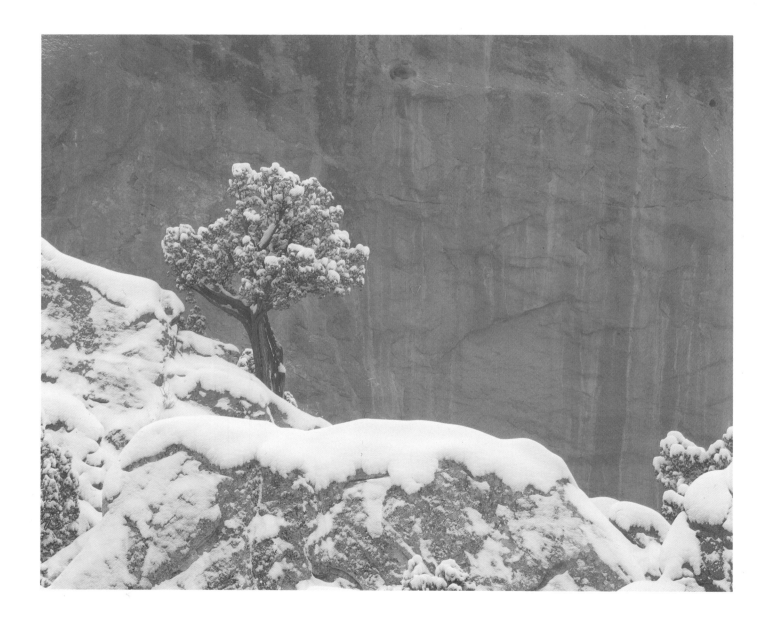

Precarious perch
Right: Blizzard conditions

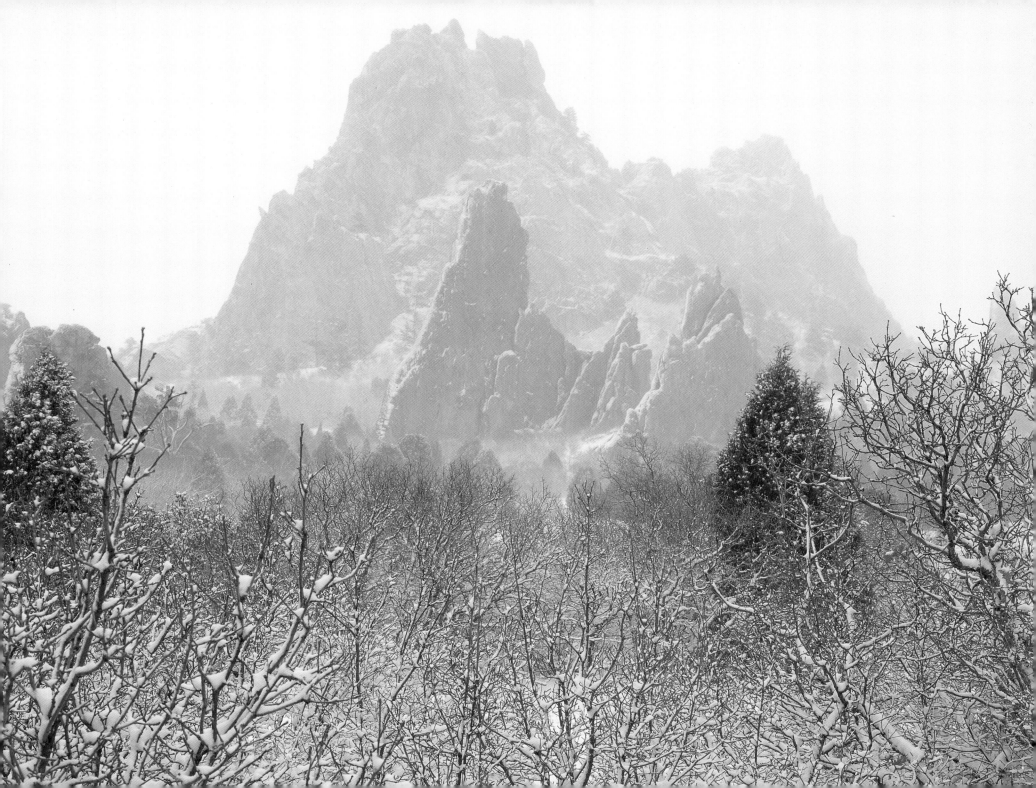

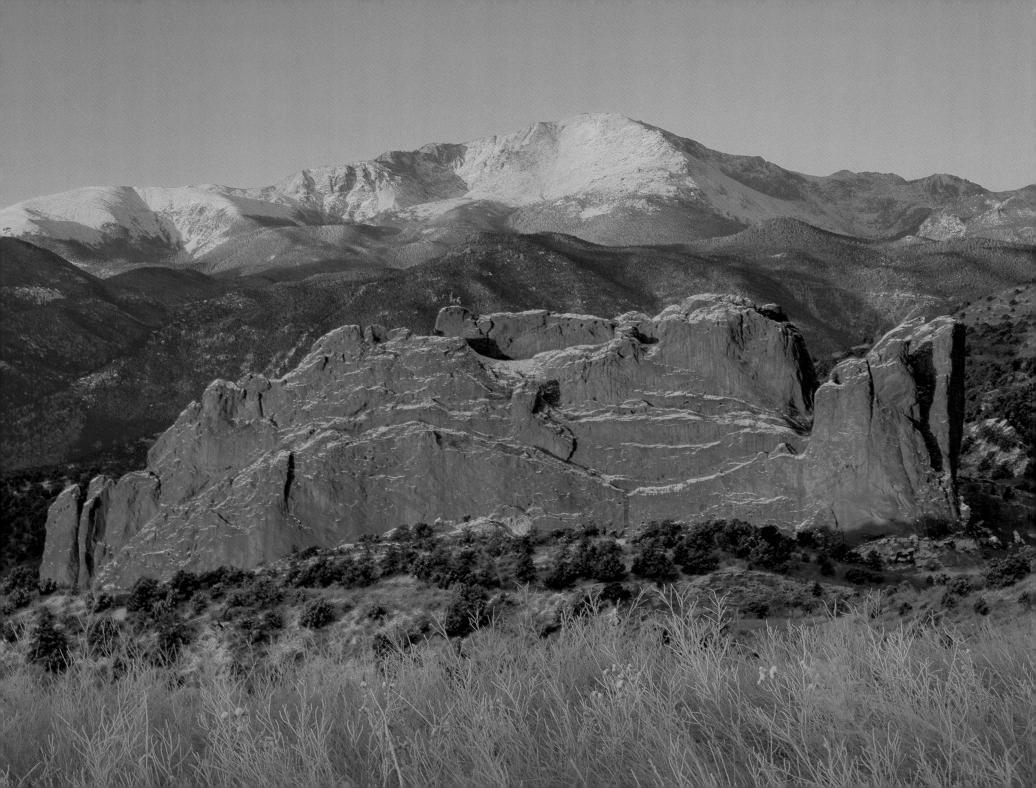

Pikes Peak & Garden of the Gods

Two Worlds~One Vision

Few places in America have such an incredible amount of scenic grandeur as Colorado. But even in such a beautiful state, the juxtaposition of Pikes Peak and Garden of the Gods is special. These truly are two worlds, separated by only a few miles, different in almost every way.

To be able to photograph two such varied worlds within one scene is to show many of Colorado's life zones in a single frame. Piñon and juniper forests thrive in the relative dryness of Garden of the Gods. Ponderosa pine, spruce, fir and aspen forests flourish on the slopes of Pikes Peak. Higher up the mountain, beyond where the trees grow, is alpine tundra, much like one would see in the vast landscapes of Alaska. Here is a world where only the heartiest plants and animals reside, scratching out their existence on wind-swept slopes. Animals breathe in half as much oxygen as they would find at sea level.

Because of the distance and elevation gain between them, differences in climate between Pikes Peak and Garden of the Gods can be surprising. While a warm spring day can usher in

temperatures in the 70s in the Garden, winter might still have a hold on Pikes Peak. Temperatures 20 to 30 degrees cooler above 12,000 feet than those at the Garden's 6,500-foot elevation mean snow comes earlier and stays longer on the peak.

Seen from Garden of the Gods, the difference in elevation between Pikes Peak and Garden of the Gods, while respectable, doesn't seem nearly as vast as when one takes a more distant view. When seen from five or ten miles away, the rocks of Garden of the Gods are mere stepping stones to Pikes Peak, which towers high above all other peaks surrounding Colorado Springs. In fact, of all the 54 peaks above 14,000 feet in Colorado, Pikes Peak has more elevation gain from its base to its summit than any other "fourteener." More than 8,000 feet separate the piñon-juniper woodlands of Garden of the Gods from the 14,110-foot summit of Pikes Peak. That change in elevation accounts for nearly all of the dramatic environmental differences between the two.

Pikes Peak and the Gateway
Left: Sunrise, New Year's Day

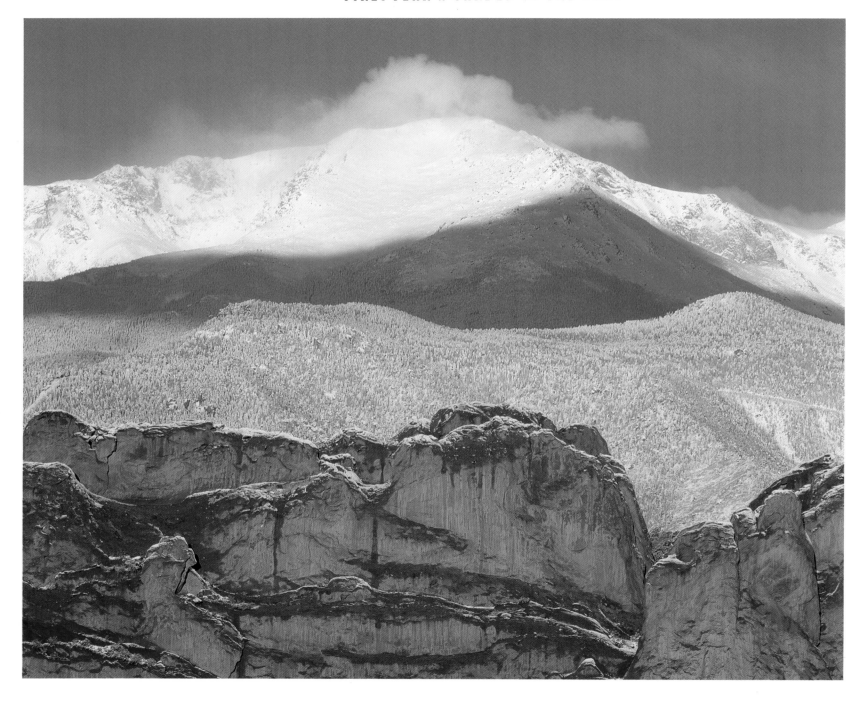

Late-season snow

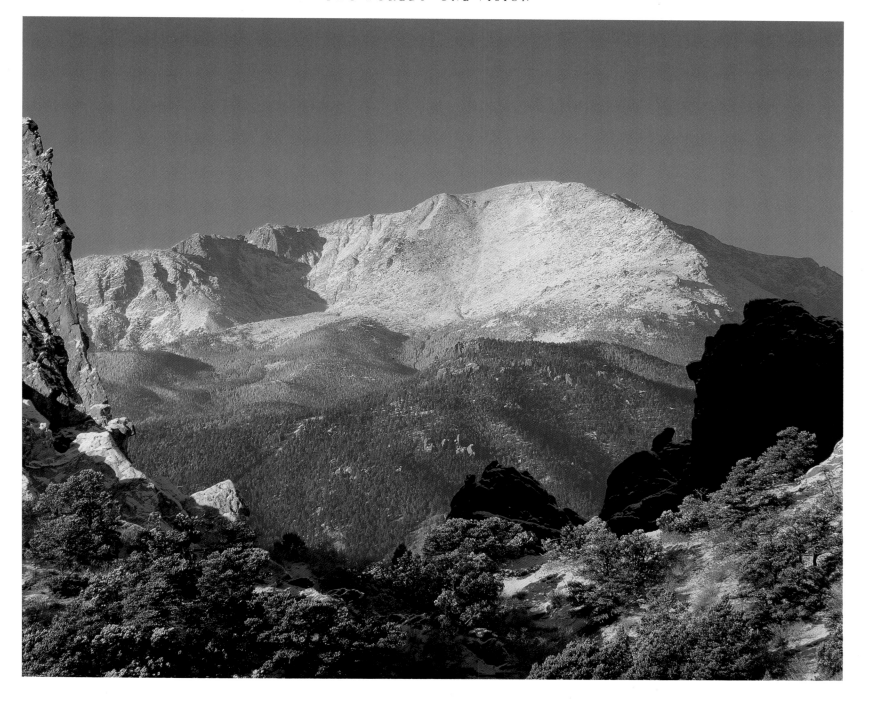

Cathedral Spires in shadow

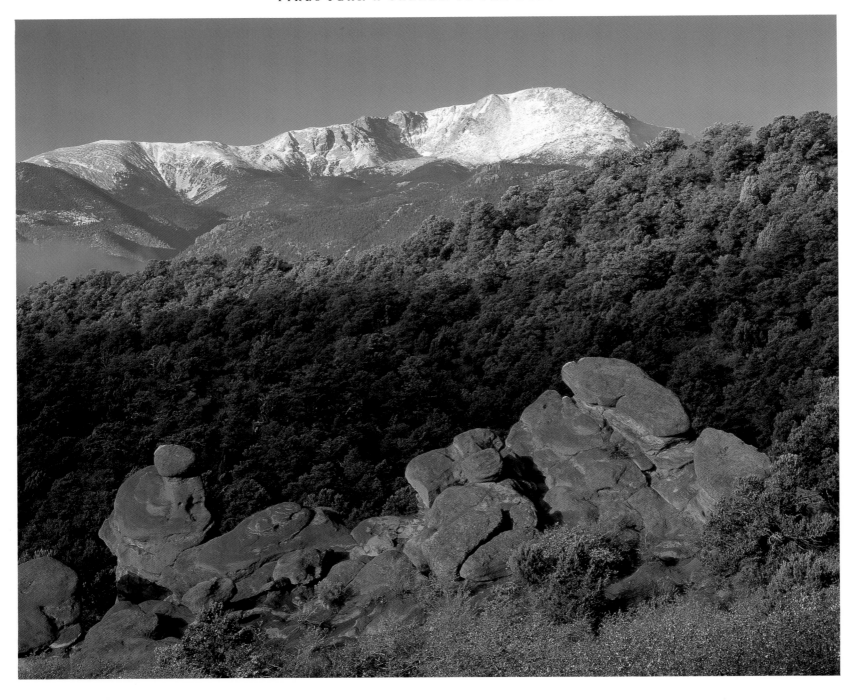

Pikes Peak and the Giant Footprints

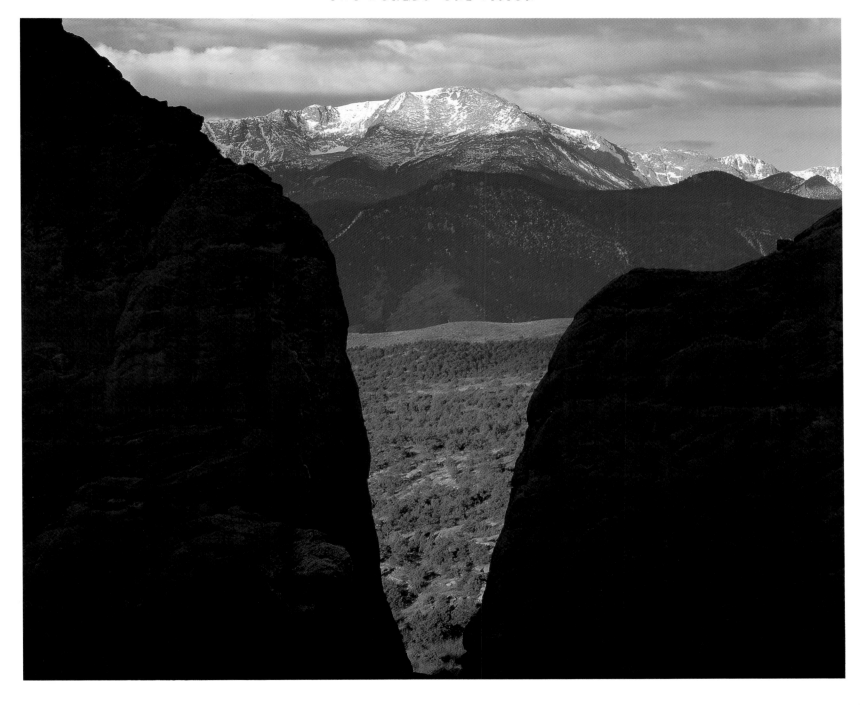

Sandstone frame

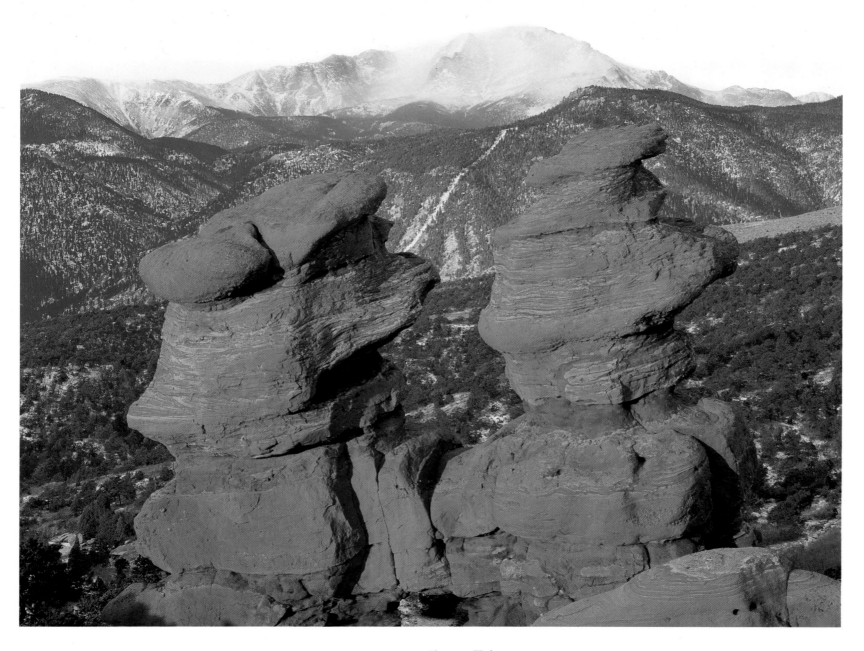

Siamese Twins
Right: Natural arch, Siamese Twins

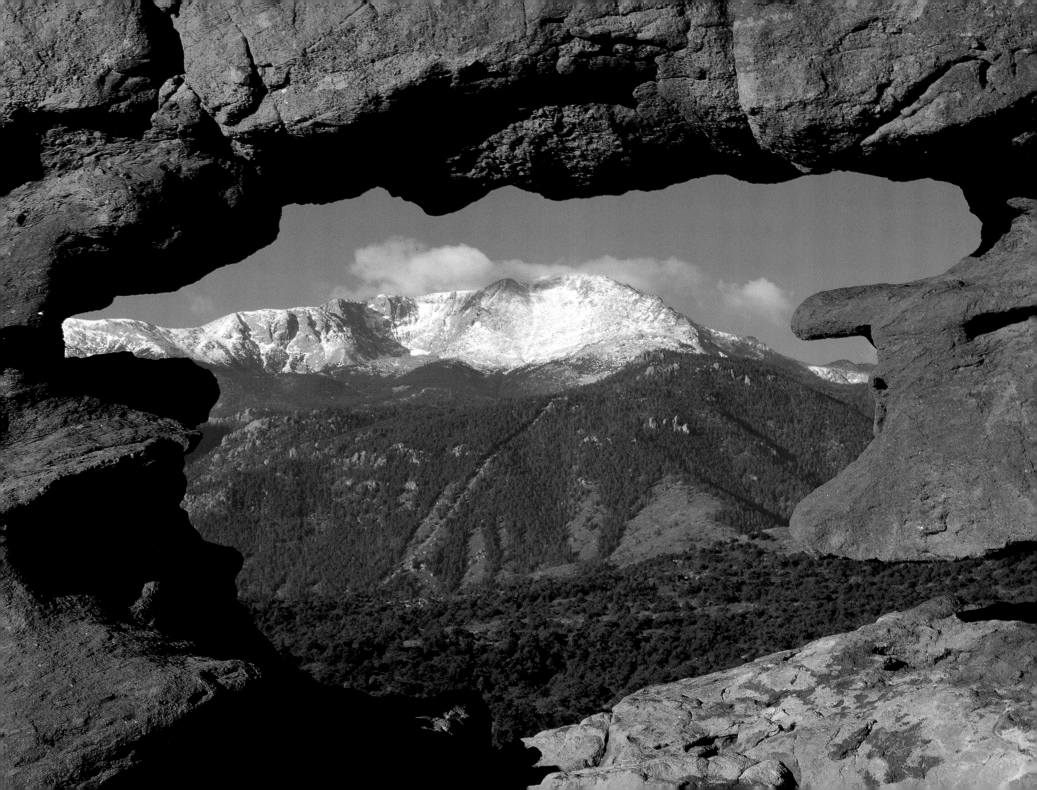

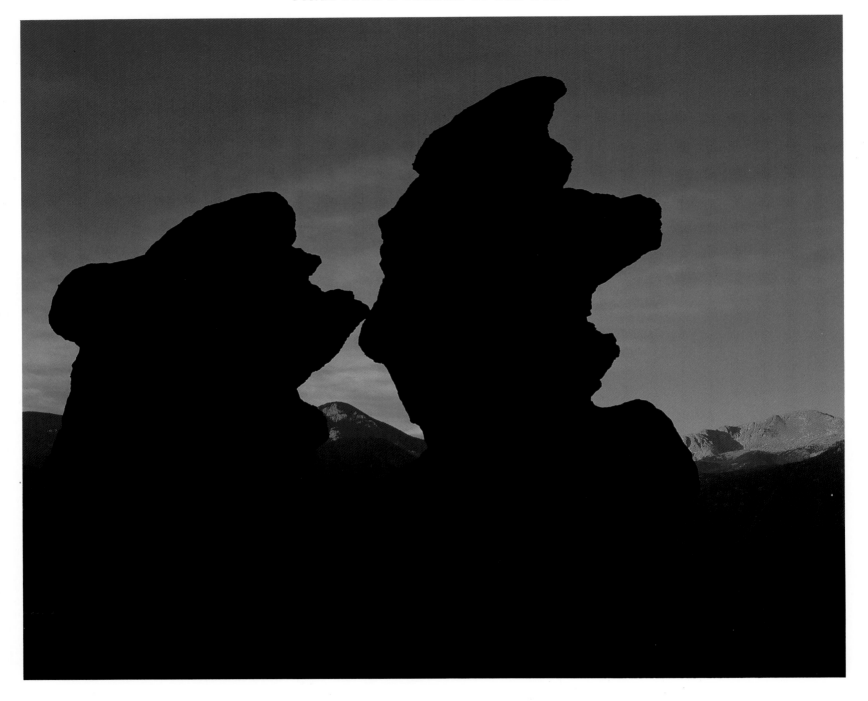

Siamese Twins silhouette

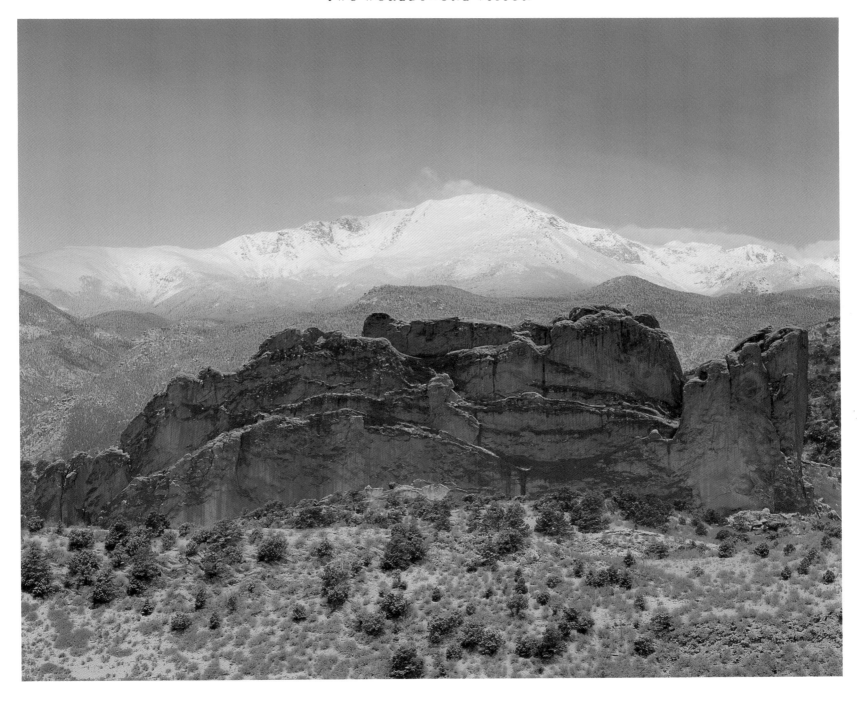

Sunlight and shadow

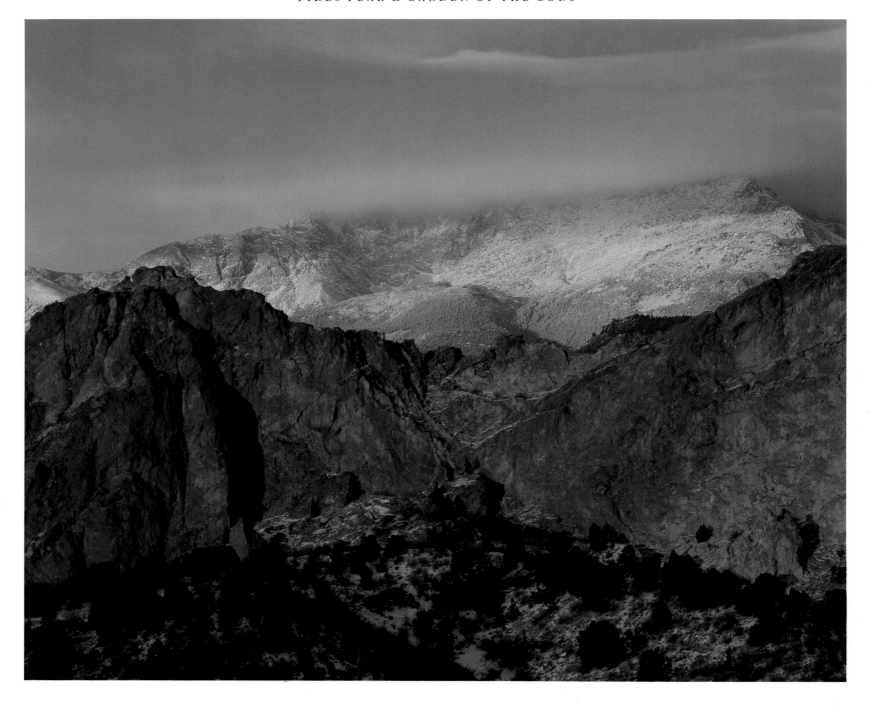

Cathedral Rock and Pikes Peak

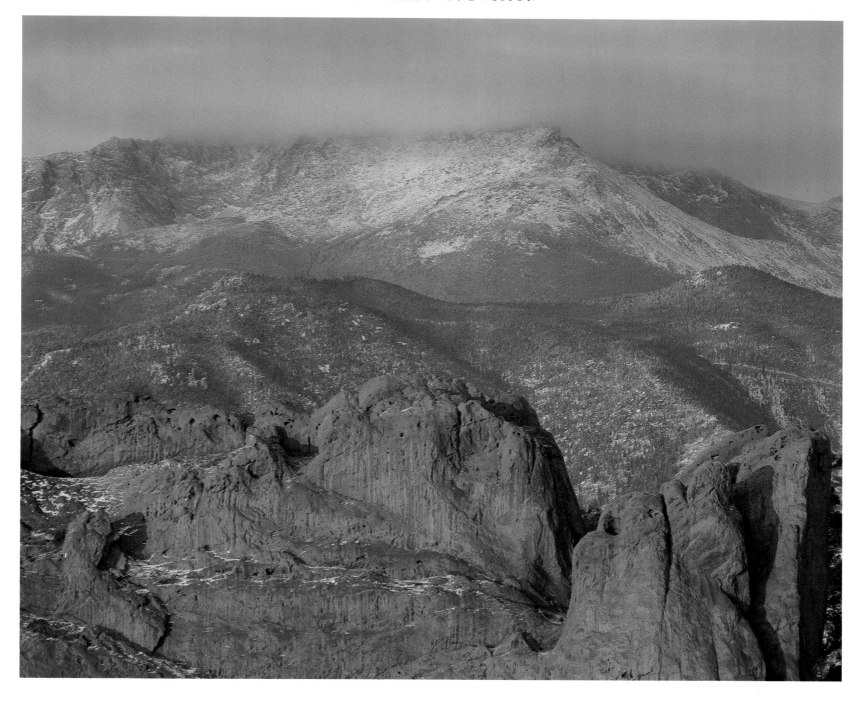

North Gateway Rock and Pikes Peak

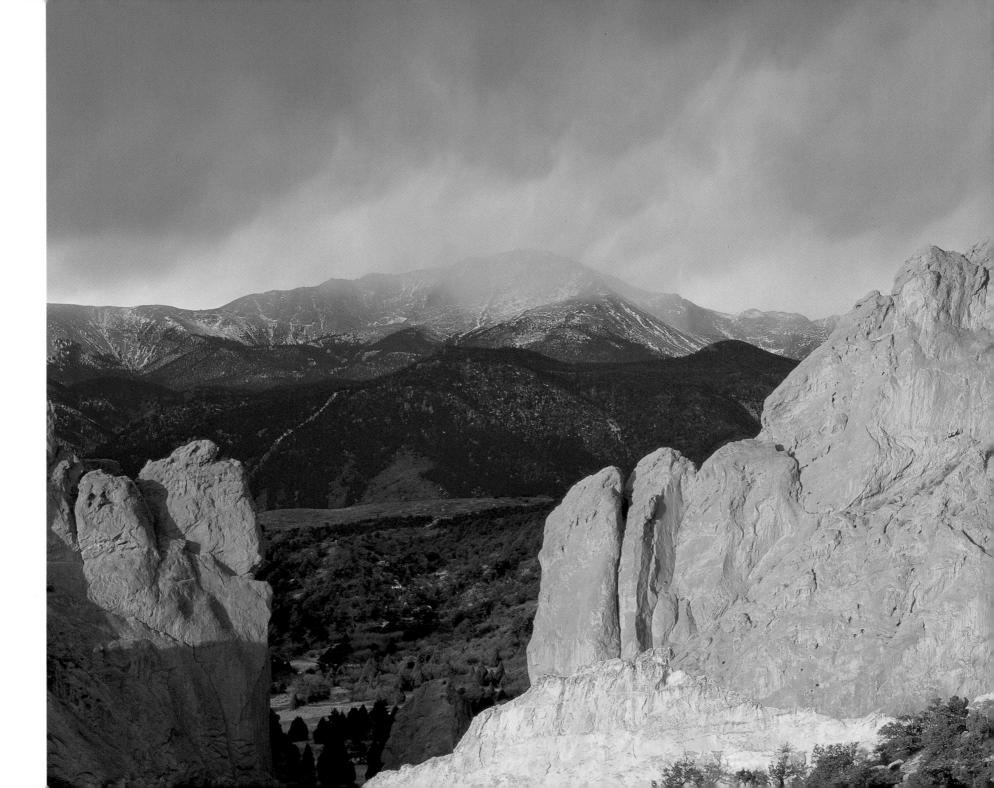

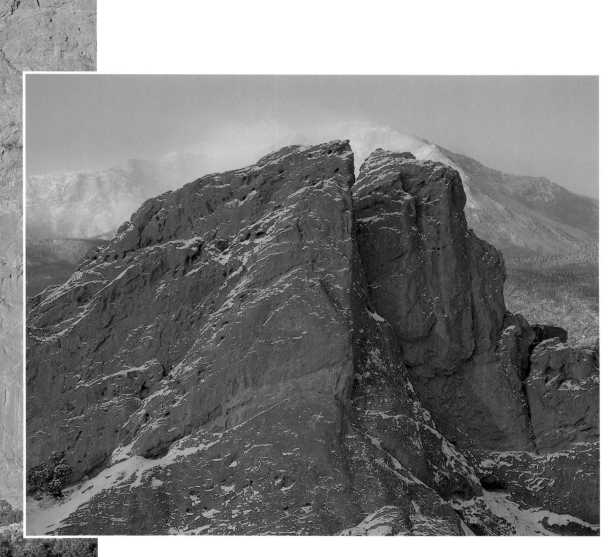

Alpenglow, Pikes Peak and South Gateway Rock
Left: Descending storm clouds

Photography Tips and Techniques

For landscape photographers, having such prominent subjects as Pikes Peak and Garden of the Gods so readily accessible pays huge creative dividends. Because of their close proximity to Colorado Springs, they're subjects that can be photographed any day of the year. Having spent many years photographing these two subjects, I've learned many valuable techniques to improve my odds of coming away with good images. I'd like to share some of what I've learned so that aspiring photographers living near or visiting the area can make the most of their time in the region.

The most important part of landscape photography is being in the right place at the right time. Although serendipity often plays a supporting role in the creation of a great image, rarely is the entire process left to chance. Photographers who repeatedly record stunning images do so because their experience has taught them what to look for in advance of that serendipitous moment. That means getting set up before sunrise, waiting out a ferocious storm, or staying tuned in to weather reports or moon calendars. Much of this "inside information" is attained through experience – that is, the more you're out there, the more familiar with the process you become. Then being there when something incredible happens becomes intuitive.

All the intuition in the world won't help you get great shots if you're too busy fumbling with your camera gear to record nature's fleeting moments. Be familiar with your equipment, as if it were merely a physical extension of your mind's eye. This, too, is something that comes with experience. Furthermore, carry your gear in such a way that it's easily accessible. If you're too concerned with protecting your favorite lens from life's little dents and dings, chances are you'll miss lots of great photo opportunities while you're frantically trying to get inside your case within a case within a case within. . .you get the idea.

Now for some specifics. To get the best photographs of Pikes Peak and Garden of the Gods, set an early alarm. Since the sun obviously rises east of these two magnificent subjects, early morning is ideal. First light often bathes both in pink alpenglow as the sun's rays scatter through the thick, hazy air hugging the horizon. The already orange sandstone in Garden of the Gods and the pinkish granite of Pikes Peak appear as if they're on fire. The contrast between this warm color and the crystal blue sky above makes for dramatic images.

Another sunrise option is when the pre-dawn sky is filled with clouds. If the sun can find a path between the clouds and the horizon, the sky will fill with red, orange and yellow color. From the central Garden area, the beautiful rock formations can be silhouetted against this color for great effect.

That's not to say that sunset isn't a good time to photograph the Peak and the Garden. I've enjoyed many beautiful afternoons in Garden of the Gods and gone home with lots of nice photos. The biggest difference is, the sun sets behind the Front Range before its rays have a chance to turn to the rich, warm color of sunset. You also cannot photograph Pikes Peak and Garden of the Gods in the same photo with frontal lighting at sunset. But late-day photography of these two subjects can still net many fine photographs. The aftermath of an afternoon thunderstorm, perhaps a fleeting rainbow or billowing thunderheads to the east, can provide images possible at no other time of day.

The key is to avoid midday light. When the sun is high in the sky, the photos lack the depth and warmth of morning or evening light.

One of the most stunning views of Pikes Peak is when it rises above a sea of clouds. Foggy days are not very common in Colorado Springs, but if one such day comes along, the chance to catch the Peak rising above it all is quite good. Watch for upslope conditions, when cool, humid, heavy air masses push against the mountains from the east. Often these fronts are not strong enough to push up and over the Front Range, leaving the city below to suffer a dreary day while the mountains are bathed in blue skies and sunshine. To find out where this sea of clouds ends, drive up

Rampart Range Road toward Woodland Park. Chances are you'll find the dividing line between the two air masses, and Pikes Peak will rise high above the grayish cloud mass. Rampart Range Road is a bit rough from its beginning at Balanced Rock to a shooting range about seven miles up, but the road can be negotiated by regular passenger cars in any season except winter. Even in winter it's often possible to drive far enough to find the top of the clouds.

Different seasons provide different kinds of images of Pikes Peak and Garden of the Gods. Although summer is when most visitors come to the Pikes Peak region, other times of the year also offer stunning photo opportunities.

In the fall, Pikes Peak's many aspen groves are ablaze with golden color. Take a trip to the summit via the toll road, Barr Trail or the Cog Railway and you'll have a chance to photograph these stunning fall colors. Rampart Range Road also is a good place to find great color. Once the semi-arid foothills around Garden of the Gods give way to the cooler, higher spruce-fir and aspen forests, it's possible to photograph groves of gold aspen trees with Pikes Peak rising in the distance. Though the timing of autumn gold can be fickle, the third and fourth weeks of September are typically the best. A good pair of binoculars in morning light from Colorado Springs can be a great tool for finding out how far along the colors are.

Autumn color in Garden of the Gods is also spectacular. By mid-October the cottonwoods in the park are adorned with yellow leaves, and the gambel oak and other ground cover plants turn a variety of striking reds and browns.

There is perhaps no more beautiful time to photograph either of these subjects than in winter. Pikes Peak isn't nearly as accessible as the Garden, but it sure makes a beautiful backdrop to the latter's incredible rock formations. Just after a snowstorm is best, when ribbons of white provide accents to the reddish Garden rocks. As the storm gives way to clear weather, you're almost assured of photographing fantastic scenes.

Including the moon in photographs can add a bit of celestial magic. You needn't resort to double exposures or other gimmickry to have the moon be an important part of your composition, though. Moon cycles are published regularly in newspapers, so it's easy to find out what phase the moon is currently in. Make a note of when the full moon and the crescent moon will happen, then follow a few easy guidelines.

If a full moon is what you're after, try shooting it setting over Pikes Peak and Garden of the Gods at daybreak a day or two after its fullest phase. That way it will look nearly full, and the rising sun will illuminate your foreground subjects. A rising full moon will look best a day or two *before* the fullest phase. Simply look to the east around sunset. To know where the full moon will rise or set, just look 180 degrees from where the sun is about to set or rise and you'll be pretty close.

Shoot crescent moon shots three to four days before or after the new moon to get the best results. Before the new moon, look to the east just before the sun comes up. After the new moon, look west just after sunset. For maximum impact, find a subject that you can silhouette against the dawn or dusk sky. A sliver of moon hanging in a deep blue sky will be an exclamation point to your composition. Just keep in mind that the closer to the actual new moon phase you get, the closer to the sun the moon will be, and the harder it will be to see.

If you've done all that you can to be at the right place at the right time, you've set up your camera and you're ready to record the most beautiful sunrise the world has ever seen, yet that sunrise never materializes, don't fret. As I often say, a bad day spent with Pikes Peak or Garden of the Gods is better than a good day sitting around the house watching television!

— Todd Caudle

Overleaf: Sunset skyline

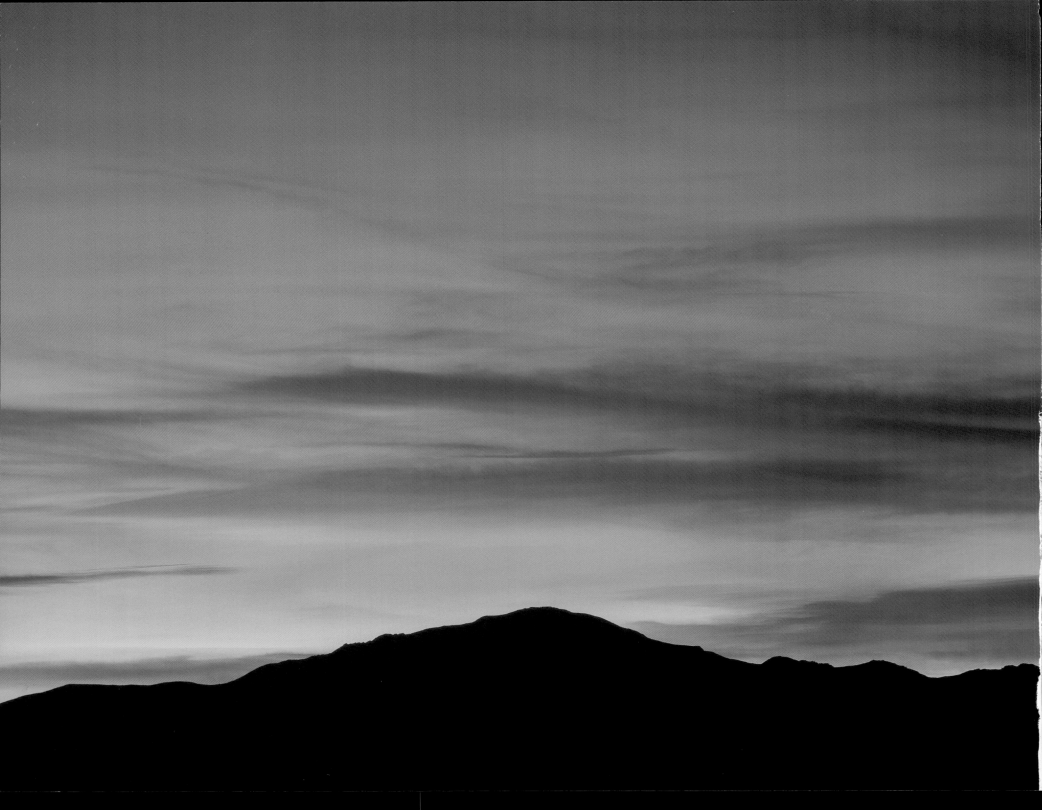